D0988971

Images of Modern America

BISCAYNE
NATIONAL PARK

Images of Modern America

BISCAYNE NATIONAL PARK

Kirsten Hines
and James A. Kushlan

ARCADIA
PUBLISHING

Published by Arcadia Publishing
Charleston, South Carolina

Printed in the United States of America

Library of Congress Control Number: 2017935301

For all general information, please contact Arcadia Publishing:
Telephone 843-853-2070
Fax 843-853-0044
E-mail sales@arcadiapublishing.com
For customer service and orders:
Toll-Free 1-888-313-2665

Visit us on the Internet at www.arcadiapublishing.com

CONTENTS

ACKNOWLEDGMENTS

We thank the many people who encouraged and helped us on this project. We particularly acknowledge the National Park Service: at Biscayne National Park, we thank especially Gary Bremen, who suggested this book and provided guidance; Charles Lawson, who generously shared his knowledge of the park's archeological history and imagery; Elsa Alvear; Kelsy Armstrong; Carissa DeCramer; Michael Hoffman; Jay Johnstone; Joshua Marano; Astrid Rybeck; Elizabeth Strom; other park staff and volunteers; and superintendents Brian Carlstrom and Margaret Goodro; at the NPS South Florida Collections Management Center, we thank Bonnie Ciolino and Katrice Brown; and at the NPS Southeast Archeological Center, we thank Charles R. Sprout and Richard Vernon. We also thank Dawn Hugh, Ashley Trujillo, and Jorge Zamarillo of HistoryMiami; Thomas N. Davidson and Lisa Dykes of the Ocean Reef Club; Christopher B. Everhart of the Key Largo Anglers Club; Ken Nedimyer and Mari Backus of the Coral Restoration Foundation; Claudia Moriarty and Breana Sowers of Monroe County Public Library; Jenny Litz of the National Marine Fisheries Service; Jill Miranda Baker, Brad Bertelli, and Jerry Wilkinson of the Florida Keys History & Discovery Center; Adam Watson and Jacklyn Attaway of the State Library & Archives of Florida; Christopher Banks of the Lyndon B. Johnson Presidential Library; Lynn Smith and Craig Wright of the Herbert Hoover Presidential Library; Diana Udel and Angela Clark of the Rosenstiel School of Marine and Atmospheric Science Library, University of Miami; Susanne Hunt of the Florida Department of State Bureau of Historic Preservation; Joshua Morgan and Rachel Wittmann of Clemson University; Joe Browder; Robin Diaz; Paul George; Cynthia Guerra; Ronald Hines; Mitchell Kaplan; Arthur Kushlan; Joycelyn Kushlan; Philip Kushlan; Kevin Lastells; Theodora Long; Lloyd Miller; Paul Naron; John C. Nordt III, MD; Nathaniel P. Reed; Mikolay "Nick" Plater-Zyberk; Paola Fernandez Rana; Tommy Sellah; John Sheldon; Edward Schultz; Joseph Wasilewski; and Kevin R.T. Whelan. Jim Kushlan would like to express his appreciation to his colleagues during the decade he conducted wildlife studies at the monument: Sonny Bass, Gary Davis, Ronald Gaby, Frank Mazzotti, Paul Moler, Oscar T. Owre, William B. Robertson, Jim Tilmant, and Deborah White. We thank Philip Kushlan, Charles Lawson, and John C. Nordt III, MD, for their reviews of previous drafts of the manuscript. We thank Ashley Harris and Liz Gurley of Arcadia Publishing for assistance and guidance. We especially thank and acknowledge the individuals who and institutions that have permitted use of images. These are listed in the key to courtesy lines on page 95.

INTRODUCTION

At the extreme southeastern edge of Florida is a remarkable body of water—Biscayne Bay, a tropical lagoon affixed to an otherwise temperate continent. Seaward, the bay is confined by shallow banks and a series of islands starting in the north with the Miami Beach peninsula. Farther seaward lie marine shallows and the continental United States' only coral reef. This book is about the bay and its adjacent landscapes and seascapes stretching from the coastal mangrove swamp to the coral reef. It is about its images, history, people, and stories. The book's photographs are all of the bay and nearby keys areas. This book especially is about Biscayne National Park, celebrating in images and stories the 50th anniversary of the park's establishment. The park preserves and protects much of the central and southern Biscayne Bay and nearby lands and waters. Our book *Key Biscayne* in Arcadia Publishing's Images of America series tells some of the story of northern Biscayne Bay.

When the Spaniards arrived, Biscayne Bay was an estuary fed by fresh water emerging from short, seasonally flowing rivers complemented by freshwater springs erupting from the bay bottom itself, all fueled by the hydraulic head provided by the vast Everglades perched just inland. To the east, tides and wind moved warm salty water of the Atlantic Ocean into and out of the bay to mix with the fresh. These waters created a diverse, productive environment with waters as clear as those of the Bahamas today. Biscayne Bay was, and is, shallow, averaging about 10 feet deep. Originally, it was lined with freshwater marshes and swamps of salt-tolerant mangrove trees. Its bottom was covered with seagrasses, sponges, algae, and soft corals. Although the freshwater flows have been much diminished and the bay's waters afflicted by decades of abuse by millions of people, much else of what early explorers saw remains, especially in the central and southern parts of the bay.

The bay's string of islands are called "keys," derived from the Spanish word *cayo*. Sandy in the north and rocky in the south, they were originally covered by mangrove swamp, coastal prairie, and hardwood forest composed mostly of trees from the West Indies. The tidal flow passes around the islands and through narrow channels, called finger channels or "cuts," as they are in the kindred environment of the Bahamas. The largest and most navigable natural cuts are towards the north: Norris Cut (historically Narrows Cut and then Nares Cut) and Bear Cut (originally Bear's Cut). Tide also flowed across shallow banks, initially called Pearl Oyster Banks then Biscayne Flats and sometimes the Safety Valve. These are so shallow that only shoal-draft vessels can pass over them and then only at high water. To get into and out of the bay, sandbars and shallow hard bottom have to be successfully transited. Other shoals, such as Featherbed Bank, cross the bay. For most of its history, the bay was not an easy place to enter, leave, or traverse and not a welcoming harbor to the inexperienced.

Eastward of the keys, cuts, and Biscayne Flats lie seagrass beds, rocky bottom, sand patches, and patch reefs. The slightly deeper Hawk Channel (originally Hawke Channel) provided early settlers with a passageway between the Biscayne Bay area and their main town, Key West, up to a three-day sail away, weather permitting. Farther eastward lies the Florida reef tract, biologically diverse and for centuries a significant hazard to ships and to mariners' lives. The warm, northward

flowing Florida Current, an arm of the Gulf Stream, is the raison d'etre of the tropical character of the Biscayne Bay area, bringing the tropical marine waters, animals, and plants that make this area biologically unique in North America. Beyond the reef and Gulf Stream are the Bahamas and Cuba, only 60 miles and 150 miles, respectively, from Elliott Key.

The bay area's geologic history began about 10,000 years ago as rising sea levels created the lagoon. When sea level stabilized 5,000 years ago, sandy islands now called Miami Beach, Virginia Key, and Key Biscayne alighted on the backbone of a 100,000-year-old fossilized reef tract. This Key Largo Limestone continued, trending south and southwest, underlying the Biscayne Flats to emerge as the northern Florida Keys, starting with Soldier Key then continuing through Elliott Key and on to Key Largo and the rest of the northern Florida Keys.

Recorded human history began about the same time, 10,000 years ago. Native Americans lived near what is now the bay's margins but were well upland. Once the bay flooded, people living along mainland rivers used the bay's islands seasonally and later perhaps more permanently. Fish, queen conch, monk seals, turtles, tropical fruits, and palms provided sufficient food and other materials to support the civilization of these hunter-gatherer, nonagricultural Indians. By the late 1500s, contact with Europeans had altered native cultures and more than decimated their population such that we find no evidence of their continued use of the southern bay or its islands.

The bay's story was grounded in its isolation. South Florida was essentially an island, surrounded by the sea on one side and inland marsh and swamp on the other. For thousands of years, people came and went by canoe, traveling coastwise or through the inland marshes, or by walking with great difficulty along the shoreline. Not until the Seminole Wars was there any land trail, and there was no wagon road until the late 1800s. Before then, transport of goods was not by land but by sea. With the bay's shallows inhibiting its use as a natural deepwater harbor, that role fell to Key West. The bay's isolation was finally breached by the railroad on land and dredged channels by sea, only a little over a century ago.

Politically, for most of its western-influenced history, the Biscayne Bay area was Spanish. Juan Ponce de León, the first European to officially reach Florida, in 1513, made the bay his second stop. Antonio de Herrera y Tordesillas reported that "between the bank and reef of islands and the mainland stands a great sea, like a bay." Ponce transliterated the name of the local Indians as Chequescá, and for over two centuries, the bay was charted as Tequesta, long after any Indians by that name had disappeared from history. The Spanish held dominion for 200 years, headquartered in St. Augustine, an inconvenient 300 miles away. Havana, under a different governor, was closer. For much of the Spanish centuries, the Biscayne Bay area was deserted save for occasional wrecked ships, Spanish and Indian salvors, and visiting Cuban and Bahamian mariners. Bahamian sailors appeared seasonally for turtling, woodcutting, wrecking, fishing, and hunting, but only a few chose to seek Spanish land grants in the bay area. During a brief 20-year rule, England made land grants, surveyed, and anglicized charted features, the bay becoming Dartmouth Stream and Sandwich Gulf. Spain briefly reclaimed Florida but facing American pressure turned the peninsula over to the United States in 1821.

It was the Gulf Stream Ponce discovered that, quite literally, put Florida's keys (Ponce's Los Martires) on the map. The reef occasionally took its toll on passing ships, especially during hurricanes, like the ones in 1622, 1715, 1733, and 1750. Grounded ships included the richly laden Spanish plate fleets carrying the goods of the Americas and Asia to Europe. Periodically, privateers and pirates worked the Caribbean, even headquartering themselves in Nassau in the early 1700s. But little or no piracy is documented along the keys or at the bay; the Gulf Steam's strong current, always threatening reefs, and distance between the shipping channels and land made the area inopportune for engagement. When the United States was handed Florida, it set out to secure its new coast by taking military control of Key West, lighting the reef tract, stopping escaping slaves, inhibiting smugglers and Bahamian salvagers, removing Indians, controlling pirates in the Caribbean, and encouraging settlement. The early wealth of the area was not in its land, which then could grow nearly nothing marketable, but in the ships that grounded on the reefs, funding a profitable wrecking enterprise, operating first from Nassau and then from Key West, which

became for a time one of the richest towns per capita in America, attracting both American and Bahamian settlers. In 1825, when the federal government built the Cape Florida Lighthouse on Key Biscayne, its comforting presence allowed the bay area to finally become attractive to American pioneers and their Bahamian counterparts. And when the United States closed wrecking and fishing to unregistered Bahamian boats and required wrecking spoils be brought to Key West, Bahamians immigrated to Key West, and from there began a slow colonization of keys northward, becoming known locally as Conchs.

In the meantime, Indians who had settled in northern Florida under pressure from American settlers and their military were pushed inexorably southward into the less and less hospitable swamps of South Florida. The resulting Second Seminole War, or Florida War, came to South Florida in force in 1836 when Indians attacked mainland settlers, the Cape Florida Lighthouse, a lightship crew, and later Indian Key. Settlers abandoned the Biscayne Bay area for the relative safety of the keys farther south, and the Army took its fight to the Indians by canoe up the Miami River, effectively ending the conflict in South Florida. The Civil War soon followed, during which the bay, having few settlers left, saw little action other than visits by the Union navy blockading the coast. No one lived on the southern bay keys.

It was only after the Civil War that settlement began in earnest, encouraged by the postwar homestead acts. The easiest way to gain a patent was by proving the land through farming. But typical farming and transporting most production to market were impractical. Early settlers grew sea cotton, which could ship, but most went to the mainland to harvest wild-growing coontie to sell as starch. It was only when pineapple cultivation proved viable that profitable farming became possible, and pineapples grew best on the keys. Carpetbaggers, American pioneers, and Conchs claimed their patches of Biscayne Bay–area lands. In 1878, the Cape Florida Lighthouse was replaced by one offshore at Fowey Rocks, and such reef-based lights, along with steam-powered ships, reduced groundings, throttling the once-rich wrecking industry. Land claims were made and proven on the islands where the tropical forest was cleared and burnt to open land and prepare soil for planting. Fishing, sponging, infrequent wrecking, hauling, and guiding brought additional income. Pioneer families were Bahamian and Key West Conchs, such as the Alburys, Filers, and Sweetings and Americans, such as the Joneses. Key West remained the southern bay area's connection to the world, and many settlers left during the summer–fall mosquito and hurricane season. Eventually, Elliott Key and its neighboring islands were thoroughly claimed and largely farmed. Owners and settlers came, and went, creating a pioneer island community of interdependent, hardy, industrious people. Plant disease and overwash from the 1906 hurricane ended pineapple farming, leaving limes as the primary crop.

The coming of the railroad to Miami in 1896 changed everything about the Biscayne Bay community. Miami soon superseded the original southern bayside towns of Cutler and Coconut Grove, and the railroad monopoly ruled the economy and politics. Miami expanded at exponential speed as a port of departure for cruising ships and an attractor of wealthy seasonal guests and new residents to service them. Some were just passing through on their way to Cuba or Nassau, some came to stay the winter, and some eventually built houses of increasing grandness. Others just wanted to have a modest home on an island. By the 1920s, the naturalness of the northern bay had been obliterated by flow-blocking causeways, artificial islands, dredged channels and their spoil, and by unabated sewage. So, southern Biscayne Bay became the new playground, populated by fishing camps and resorts for the rich and the famous. In the 1920s, an odd community of beached barges and boats started developing on the Biscayne Flats. Prohibition encouraged smuggling of liquor through the bay from the Bahamas. Miami's boom ended when over-demand for supplies clogged railways, the Great Miami Hurricane of 1926 wreaked unexpected devastation, a capsized vessel blocked the port of Miami, and the 1930s Depression destroyed economic opportunities. Faced with these realities, the early planters moved from the keys, selling their lands to a new crop of owners who built their own shacks, homes, hotels, guest lodges, fishing camps, and even an alcohol rehabilitation center. But much was still wild, and abandoned sites were soon recovered by forest.

There was some delay until Miami's development lust reached the central and southern bay in force, but eventually the area drew the attention of seriously development-minded people and corporations. A 1950 county proposal for a causeway from Key Biscayne to Key Largo energized dreams of dredging up new land, development, and profits. In 1961, landowner-voters created the municipality of Islandia out of the 33 southern bay islands. Plans for industrial developments on the mainland emerged. In 1963, Florida Power and Light announced its intention to build oil-fired power plants at Turkey Point. To avoid heating the bay, FPL eventually dug miles of cooling canals on the mainland. On northern Key Largo, developments failed or prospered little by little, successes being Ocean Reef and the Key Largo Anglers Club.

As development pressures increased, a movement to "Save the Bay" and nearby areas began. A report to Secretary of the Interior Stewart Udall attested that "here in shallow water is a veritable wonderland." Through the 1960s, persuasive public engagement materialized for protection of north Key Largo, southern Biscayne Bay, and offshore waters. Crucial politicians came around. In 1963, offshore from Key Largo, the state established John Pennekamp Coral Reef State Park. And in 1968, the US Congress established Biscayne National Monument. During the 1970s, National Park Service staff slowly established the monument, acquiring inholding lands, removing existing structures, freeing habitats to restore themselves, and better understanding natural and cultural resources. Nearby areas were also protected. In the early 1980s, on Key Largo, the Crocodile Lake National Wildlife Refuge and the state's Dagny Johnson Hammock Botanical Park were established. In 1990, the Florida Keys National Marine Sanctuary was created, encompassing the keys' marine environment. By then, much of the bay, the coral reef, and upper keys were government protected.

The national monument's boundary was redefined in 1974 and 1980, when it became a national park, eventually covering 270 square miles, all but 14 being water, stretching from the reef, across the keys, and onto the mainland, and from near Key Biscayne to near Key Largo. Hurricane Andrew in 1992 destroyed structures, old and new. Slowly, the park reemerged, with its infrastructure restored. Surviving Stiltsville structures and the Fowey Rocks Light reverted to the park. More and more boaters discovered the park as a place to go on weekends and on holidays, such as Columbus Day weekend. This national park is ensconced within the nation's seventh-most populous county, with over 2.6 million inhabitants owning over 60,000 boats. Over a half-million people visit its waters annually.

It had taken centuries for it to really sink in: this bay, its islands, its offshore shallows, and its coral reef were natural and historic treasures that might just be worth protecting. As is the case with most resources, they had needed first to be used and abused before becoming appreciated. The region evolved from a land of visiting Bahamian turtlers and woodcutters, and later wreckers, plantation owners, and developers, into, finally, a park for all people to enjoy and to experience the area's biological diversity and historical heritage. Generations of settlers and transients appreciated the bay and its natural resources, each from his or her own perspective. The bay is not what it once was; no one today would mistake its green-tinted waters for the gin-clear waters of the Bahamas. But the keys are once again covered with West Indian forest and ringed by tropical mangroves, which look to the uninitiated as if they have been there forever. The bay area is still home to crocodiles, manatees, frigatebirds, cuckoos, reef fish, and endangered species of butterflies, cactuses, and palms. Biscayne National Park remains a special place, a tropical place, a place apart from the neighboring megalopolis, accessible only by boat—as it has been for centuries—protecting one of the nation's natural treasures and available for the use and enjoyment of current and future generations.

One

INDIANS, EXPLORERS, AND PIONEERS

Of most of the Biscayne Bay area's thousands of years of human occupancy, little evidence is left. Artifacts from Sands Key show its use from 2,500 years ago up until the mid-1600s, by which time local populations of indigenous people had collapsed. The bay entered western history with Juan Ponce de León's landing on Key Biscayne. The freshwater sources he found in the bay attracted mariners for centuries. Evidence of 200 years of Spanish dominion is slight, amounting to objects shipwrecked, washed ashore, or left behind by the Indians in their middens. In the mid-1700s, England set to work surveying land grants and imposing English names for landmarks, a few of which stuck. Bahamian mariners worked the area in both Spanish and English periods. Returned to Spain in 1818, Florida was turned over to the United States only three years later. The United States immediately sent the Navy, settled Key West, and built the Cape Florida Lighthouse. With a few local Spanish land grants endorsed, a small number of settlers began to occupy the land. Although agricultural opportunities were minimal, salvors out of Key West profitably worked the reefs. Indian attacks of the Second Seminole War stripped the bay area of settlers but brought a combined force of the Army and Navy. After the war, a few settlers returned, the reef tract and keys were charted, and the reef itself studied. Further settlement was stymied by the Civil War, during which the southern bay was uninhabited, but afterwards, homesteaders and others came, developing a mixed economy of fishing, sponging, wrecking, transporting, guiding, and farming pineapples and key limes on cleared land. Most of these pioneer residents remained allied to Key West until the railroad and explosive development of Miami took control of the region's economy and future.

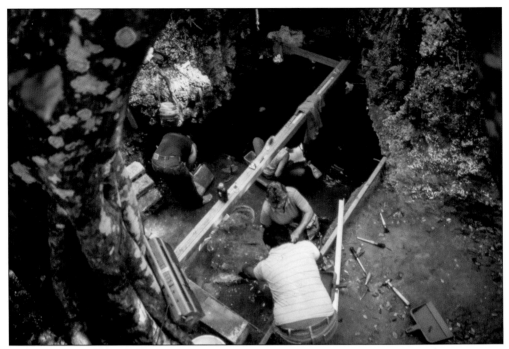

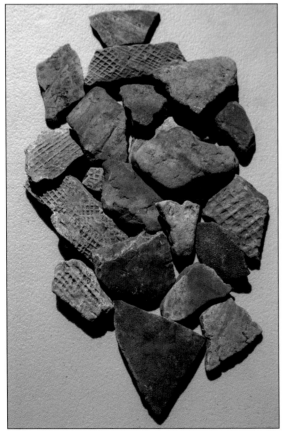

Paleo-Indian presence in the area 10,000 years ago is evidenced by deposits in a solution hole now located on the Deering Estate at Cutler. Bison, camels, condors, dire wolves, horses, jaguars, mastodons, saber-toothed cats, and tapir remains show that the site was then upland. This image is of the site's excavation in the 1980s. Biscayne Bay was not yet formed when humans first inhabited South Florida. (HM.)

By 2,500 years ago, people known to archeologists as the Glades Culture occupied the bay area, harvesting sea life and accumulating middens of debris at their living sites. Incised pot shards, shown here, demonstrate Glades culture occupancy on Biscayne National Park islands after about AD 1200. The evolving culture lasted until the mid-1500s when indigenous Native American society was overwhelmed by Spanish influences. (KH-NPS.)

Before and during European contact, native peoples lived in villages along mainland rivers and camps on the keys. They left midden mounds on Totten and Sands Keys, the latter called Las Tetas by the Spanish for two hills then visible from the sea. The middens show that these hunter-gatherers ate fish, turtles, conch, and fruit. National Park Service archeologist Charles Lawson is shown at the Sands Key midden. (NPS.)

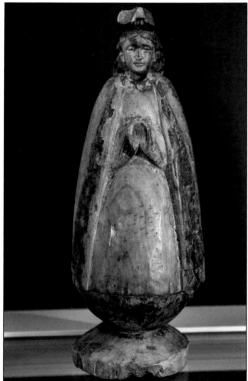

After Ponce de León arrived at Key Biscayne on May 4, 1513, he named the next major island south Santa Pola, which would be Elliott Key or perhaps Elliott plus Key Largo. Among the few remnants of the Spanish era in the bay area is this carved wooden Madonna found washed up in Elliott Key mangroves by island resident Virginia Tannehill. (KH-NPS.)

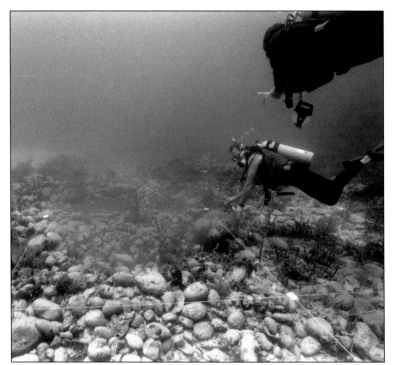

From 1566 to 1790, Spain's Flota de Indias periodically sailed along the Gulf Stream through the Florida Straits, with the wealth of the Americas and Asia aboard. In 1733, a hurricane hit the fleet driving one of the support ships, the *Nuestra Señora del Populo*, north into what is now Biscayne National Park. This image shows what is left of the *Populo* shipwreck site being surveyed by archeologists. (SAC.)

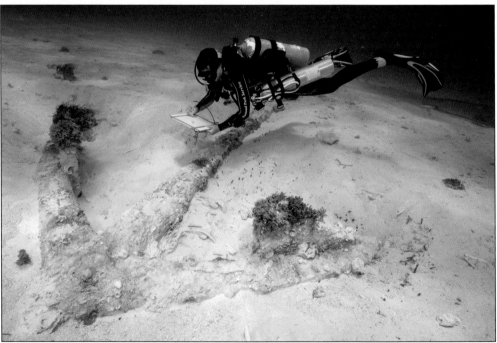

Another famous shipwreck was the English HMS *Fowey*, grounded in 1748 and scuttled in the Legare Anchorage. Its 1975 rediscovery led to a court ruling making such wrecks archeological sites rather than salvage opportunities. By then, the ship's name had been applied to the reef miles to the north. Here, archeologists investigate the *Fowey*'s anchor. A national historic district in the park commemorates the reef's many shipwrecks. (NPS.)

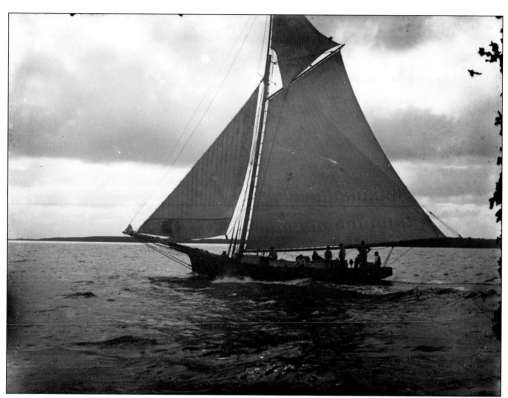

Even when Florida belonged to Spain, as early as the 1730s Bahamian mariners came to the area for fish, turtles, tropical wood, and salvage. After 1825, being required to register and return salvage to Key West, some Bahamians moved there. Wrecking became the dominating commercial enterprise of the area, underpinning the thriving economy of Key West. Shown is the wrecker *The Moccasin*. (RM-HM.)

BLACK CÆSAR'S
CLAN

A FLORIDA MYSTERY STORY

BY

ALBERT PAYSON TERHUNE
AUTHOR OF "LAD: A DOG," "BLACK GOLD," "BRUCE," ETC.

NEW YORK
GEORGE H. DORAN COMPANY

Pirates and privateers sailed the Caribbean, but there is no evidence for pirate activity locally. So what about Black Caesar? This famous story is best appreciated as a founding legend of Miami, originating with early Bahamian settlers, who also influenced British surveyors naming creeks. The story was retold by settlers, learned by newcomers, and appropriated by authors Kirk Munroe and Albert Payson Terhune in their fiction. (UCL.)

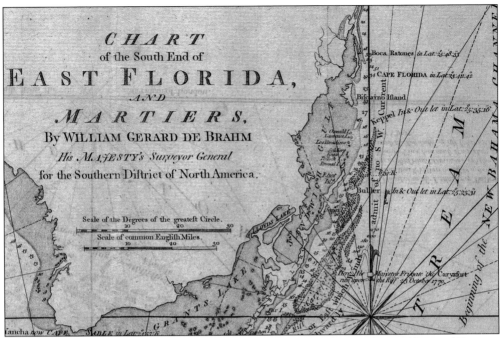

England required grantees to survey their land, so William Gerard De Brahm and Bernard Romans ventured to the area. Romans preferred historic names; De Brahm made them up, as in this 1775 map. A few stuck, including Eliot Island and Hawke Channel, both paeans to influential British officials. "Saunders" Cut evolved into "Sands," influenced by the local Bahamian-derived dialect, explaining the name of a nearly sandless island. (LMC.)

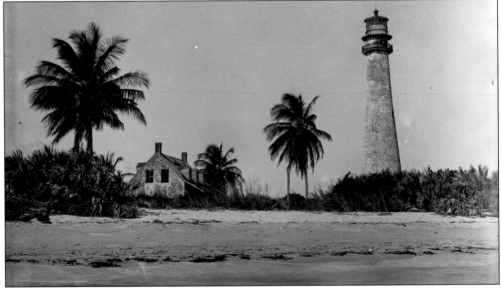

Spain gave Florida to the United States in 1821. By 1825, a lighthouse was placed on Key Biscayne. Offering a reassuring presence in this otherwise isolated region, the lighthouse encouraged settlement. It was so important that the bay was called Key Biscayne Bay until the latter 1800s. In 1836, a local Indian band attacked the lighthouse, killing the assistant keeper, and bringing the Second Seminole War to the bay. (RM-HM.)

With the Seminole War over, the lighthouse was relighted in 1847, and settlers began returning. In 1849, the US Coast Survey undertook mapping the area, triangulating from a baseline on Key Biscayne. Led by Alexander Bache, Benjamin Franklin's great-grandson, and conducted by Frederick Gerdes, the survey fixed local place-names such as Miami; Soldier, Ragged, Arsenicker, and Elliotts (now Elliott) Keys; and Black, Convoy, and Turkey Points. (SAF.)

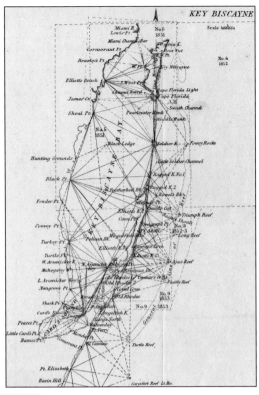

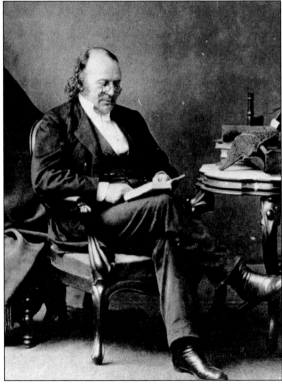

In 1849, Harvard's Louis Agassiz, shown, was commissioned to conduct a biological survey of the reef, mostly to see if it could be managed better to protect ships. His reports, from 1851 to 1880, revealed the reef was not only alive but highly diverse. Agassiz's work initiated decades of scientific study, making this reef one of the most extensively examined in the world. His practical ship advice: light the reef. (NOAA.)

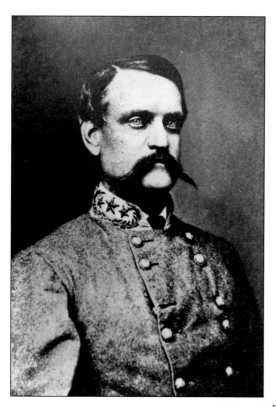

Just before the Civil War started, the Cape Florida light was extinguished by Confederate partisans, but the United States remained in control of the bay. With the war ending, Confederate secretary of war John Breckinridge, shown, sailed down Biscayne Bay and through Caesar Creek to Cuba. For not the first time, or the last, the southern Biscayne Bay area was used for surreptitious passage into or out of the United States. (HM.)

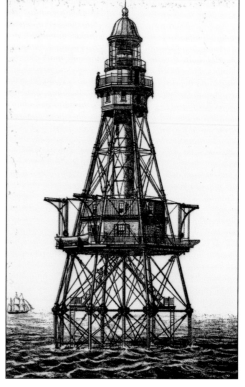

Risks to mariners posed by Cape Florida's shore-based lighthouse led, in 1878, to its replacement by one located on the reef itself, at Fowey Rocks, finally enabling passing ships to discern the seaward edge of the reef tract. Shining on to this day, the Fowey Rocks Light is a skeleton-frame cast-iron structure with its piles screwed into the reef and a two-story keeper's house on a central platform. (SAF.)

For centuries, the Biscayne Bay area has been an epicenter for smuggling weapons, alcohol, drugs, and immigrants. In the 1890s, gun smuggling to Cuban rebels was inspired by Jose Marti's agitating in Key West. Elliott Key Conchs supported the rebel cause, as did Napoleon Bonaparte Broward. Broward's steamship, *Three Friends*, is shown here transporting gunrunners in 1896. Broward became a progressive but Everglades-draining Florida governor. (SAF.)

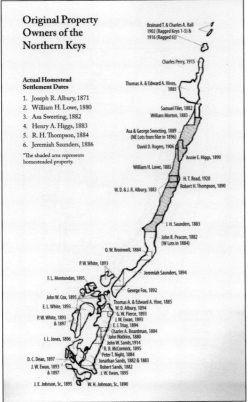

Original Property Owners of the Northern Keys

Brainard T. & Charles A. Ball 1902 (Ragged Keys 1-5) & 1916 (Ragged 6))

Charles Perry, 1915

Thomas A. & Edward A. Hines, 1885

Actual Homestead Settlement Dates

1. Joseph R. Albury, 1871
2. William H. Lowe, 1880
3. Asa Sweeting, 1882
4. Henry A. Higgs, 1883
5. R. H. Thompson, 1884
6. Jeremiah Saunders, 1886

*The shaded area represents homesteaded property.

Samuel Filer, 1882
William Morton, 1883

Asa & George Sweeting, 1889 (NE Lots from filer in 1896)
David D. Rogers, 1906

Annie E. Higgs, 1890

William H. Lowe, 1885

H. T. Read, 1920
Robert H. Thompson, 1890

W. D. & J. R. Albury, 1883

J. H. Saunders, 1883

John R. Peacon, 1882 (W Lots in 1884)

O. W. Bromwell, 1884

P. W. White, 1893

Jeremiah Saunders, 1894

F. L. Montondan, 1895

George Fox, 1892

John W. Cox, 1895
E. L. White, 1893
P. W. White, 1893 & 1897
I. L. Jones, 1896

Thomas A. & Edward A. Hine, 1885
W. D. Albury, 1894
G. W. Pierce, 1893
J. W. Ewan, 1893
E. J. Triay, 1894
Charles A. Boardman, 1884
John Watkins, 1880
John W. Sands, 1914
R. R. McCormick, 1895
Peter T. Night, 1884
Jonathan Sands, 1882 & 1883
Robert Sands, 1882
J. W. Ewan, 1895

D. C. Dean, 1897
J. W. Ewan, 1893 & 1897

J. E. Johnson, Sr., 1895 W. H. Johnson, Sr., 1890

It was only after the Civil War that settlement started in earnest. The year 1871 saw the earliest claim on Elliott Key, by Joseph R. Albury. By the 1880s, the bay's keys supported over 40 claims, including southern Biscayne Bay's pioneer families of William D. Albury, Henry Filers, Arthur and Edgar Higgs, Henry Pinder, Alfred Acheson, and the Sweetings. (LM.)

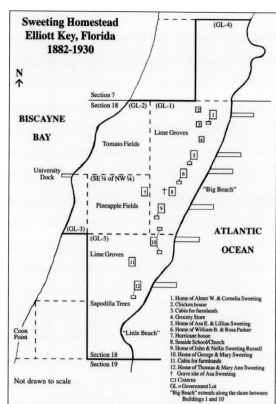

In 1882, Asa and Lillian Sweeting and sons Thomas and George homesteaded Seagrape Point. Coming from similar Bahamian cays, they became successful rock island farmers, as well as successful mariners, shipbuilders, and businessmen. The family lived on the key for 50 years and later were among Islandia's founders. Descendent Peg Niemiec captured their story. Their homesite is in the National Register of Historic Places. (PG-HM.)

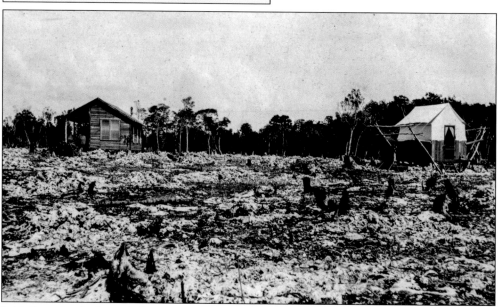

Initially settlers built simple houses, mostly on the sandy ridgeline located just above the ocean-side rocky shore. Docks extended past the shallow water to accommodate boats. Pioneer homesteaders cut and burned the tropical forest, pulverizing the limestone. Over the years, they farmed pineapples, limes, coconuts, tomatoes, yams, papayas, bananas, guavas, mangoes, chickens, and hogs. Many other plants were brought in as well. (HM.)

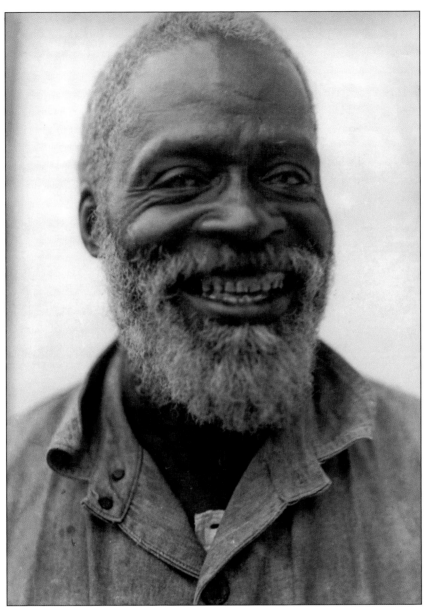

In 1897, Israel Lafayette Jones (shown in the early 1920s) found work and met his Bahamian wife, Mozelle, at Coconut Grove's Peacock Inn. Having proved his seamanship, Jones was engaged by Ralph Munroe to manage Waters Davis's Key Biscayne estate. Later, Jones bought Porgy Key from W.D. Albury and then Totten and part of Old Rhodes Keys. Building his family's home in 1912, he became a successful farmer, lime producer, manager of other groves, community leader, preacher at Mount Zion Baptist Church (and so was called parson), and founder of a Jacksonville school that would become Florida Memorial College. In the pioneer days, the bay's white and black communities lived separately but were interdependent for their survival. But Miami soon reflected the rest of the Jim Crow south with a strong Ku Klux Klan presence. Nonetheless, when "Pahson" retired from farming in 1929, he was independent, prosperous, and universally respected. A century of the bay's history is captured by the Jones family story. His homesite is in the National Register of Historic Places. (RM-JN.)

Pine apples

Southern Biscayne Bay keys' first main crop was pineapples, which thrived in the limestone and more or less shipped well to a welcoming northern market. By 1910, more than a dozen families were raising "pines" on Elliott Key. Fruit was sent to Key West for packing or directly northward. Transport was initially coastwise via boat. Pineapples created an agricultural economy in South Florida where none had been able to exist before. (SAF.)

Salty spray and storm surge from 1906's hurricane destroyed the pineapple economy. By 1925, limes had become the most important southern Biscayne Bay crop, with Elliott Key–area groves producing 7,500 barrels annually. This image is of a Mr. Stewart sitting by an Elliott Key lime tree. "Sours" were farmed on the keys for over 50 years. Many were sold locally in Miami for limeade. (HM.)

Early settlers also fed themselves by fishing. Fish and other seafood were still plentiful then and it did not take much effort to head out in a boat and gather dinner. This image shows a catch of lobsters the size of which would never be duplicated around Biscayne Bay today. These lobsters, photographed by noted naturalist and botanist John Kunkel Small, were caught off Old Rhodes Key in 1915. (SAF.)

The southern bay community was a maritime one. Into the 1900s, boats were the only transport. Sturdy, shallow-drafted boats, large and small, sailed with keen local knowledge allowed settlers to also transport cargo and passengers, charter, guide, wreck, and fish. The *Newport*, shown, ran between Key West and Key Largo. Residents sailed among Cutler, Coconut Grove, Miami, the keys, Havana, Jacksonville, Charleston, and New York. (RM-MCPL.)

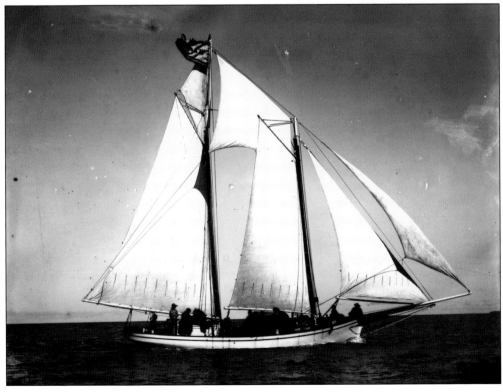

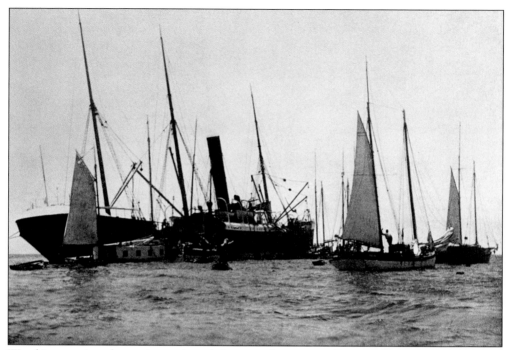

Wrecking continued as an intermittently lucrative business, so Biscayne Bay pioneers registered their boats to participate. This 1905 image shows some of over 70 salvors, including Bahamian boats, working on one of the later wrecks, the steamer *Alicia*, which grounded on Long Reef with over $1 million of cargo. What remained after salvagers demolished the ship can be viewed on Biscayne National Park's Maritime Heritage Trail. (HM.)

Soon, Miami's visitors heard about the fish to be caught down south, creating a guiding and sportfishing industry that still exists. Operating out of the Royal Palm Hotel, Charlie Thompson was one of the first fishing guides, shown here with client Fred Grakes in 1909. In 1912, Carl Fisher mounted a 45-foot whale shark Thomson killed off Pigeon Key and sent them both on tour. (HM.)

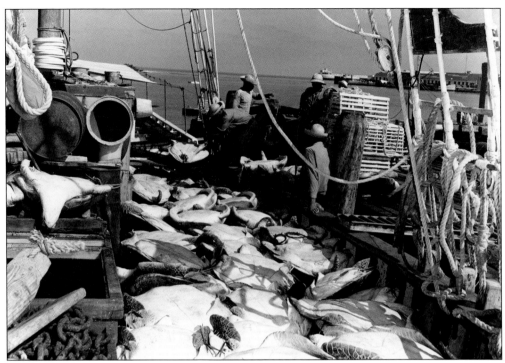

Sea turtles provided food for mariners for centuries. Biscayne's seagrass flats were nursery grounds for juveniles, and beaches provided nesting sites. Bahamian and Cuban fishermen turtled the bay area in the 1700s and early 1800s as did locals until the late 1900s. Green turtles became a staple of commerce and diet. Overharvest ended the fishery, after which the Key West turtle soup canning industry had to depend on imports. (SAF.)

Sponges also provided a commercial fishery. Led by Bahamian-derived families, such as the Thompsons, Roberts, and Russells, by the 1890s over 100 sponge boats were participating in a million-dollar industry. Several species of commercial-grade sponges were hooked with long poles, placed in crawls, cleaned, and transported to market, primarily Key West. Overharvest, disease, and new technology resulted in the early incarnation of this industry moving to Tampa. (K-H.)

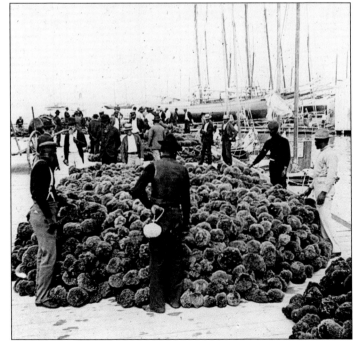

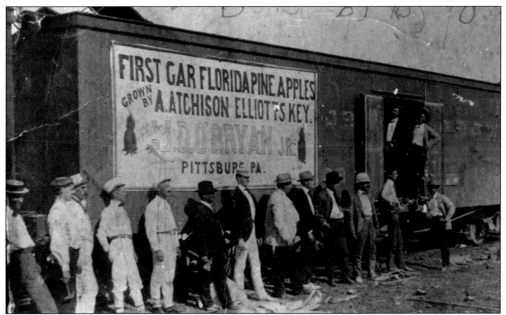

The railroad coming to Miami in 1896 and to Key West in 1912 unalterably changed the bay community. It carried tourists and new residents and handled cargo, including shipping the bay's limes and pineapples to northern markets, shown here. The railroad was a monopoly, and its offering preferred fares to Mexican shippers eventually undermined many local lime plantations that depended on shipping north. A local market for limes persisted. (MCPL.)

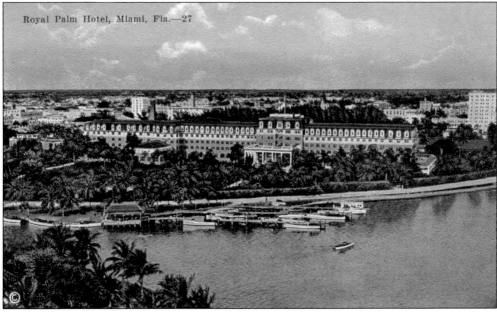

The railroad created a city its officers called "Miami," eroding the bay community's long identification with Key West. This image of the Royal Palm Hotel on the Miami River from about 1900 suggests the rapid intrusion of modern civilization only 20 miles from Elliott Key. Sail gave way to powerboats, quickening transport. With transportation, tourism, and increasing population driving the economy, the pioneer ways were ending. (K-H.)

Two

THE PRIVILEGED
AND THE DREAMERS

Development of Miami and Miami Beach, with its insatiable dredging, filling, and building, laid waste to the natural context of northern Biscayne Bay. Pollution from a rapidly growing population was exacerbated by increasingly limited tidal circulation as man-made islands and causeways blocked flow. Attention turned to the more pristine southern portions of the bay. Some of the southern bay area pioneers sold their land to a new generation of owners who dreamed of living apart in rustic shacks, or of running fish camps, or of enticing Miami's wealthy to visit and recreate, or of selling and reselling plots like they did on the mainland. Old homesteads were replaced by private retreats and lodges. Hotel owners and the superwealthy bought islands that they developed for themselves and their guests. Miami's hoteliers, in particular, found the southern bay to be an attractive recreational alternative for their guests, offering boating, fishing, and a controlled sense of adventure. Camps of varying degrees of class came to dot the southern bay from the Biscayne Flats through the keys. Fishing was becoming a national pastime. From 1911 to 1926, while also fishing, Zane Grey wrote his famous books, screenplays, and articles from a cabin on Long Key. Presidents came to the southern bay area to fish, with their exploits being widely publicized. The southern bay, reef, and big-game waters beyond provided diverse fishing opportunities. All this interest further connected the southern bay to Miami and expanded economic opportunities for locals in sport fish guiding, island management, and providing fish and shellfish for visitor dining. On northern Key Largo, which unlike Elliott Key had a road connection to the mainland, fish camps expanded into exclusive clubs and residential communities. The final bell for the old homestead families was the Depression. As they gave up their lands, there were buyers wanting them, ones still wealthy despite the Depression or those seeking to buy cheap. From 1900 through the 1930s and into the 1940s, the rich and the powerful came to the southern bay area as neighbors to the residents and dreamers who lived there.

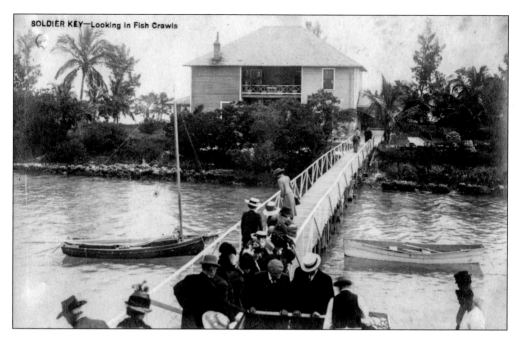

SOLDIER KEY—Looking in Fish Crawls

Henry Flagler's main goal in bringing his train to Miami was to provide ongoing connections to his Bahamian and Cuban tourist properties and to ferry freight to and from the Caribbean. He dredged the Miami River and a ship channel, dumping the fill wherever and blocking water movement and local boats. He eventually had the federal government slice through the Miami Beach peninsula for an even better channel. Soon Flagler's eyes fell on convenient, tiny Soldier Key, the first of the Florida Keys, five miles south of Cape Florida. In 1904, in a preview of things to come, he opened his Soldier Key Club for guests from the Royal Palm Hotel who were brought there by his steamer *Louise*, landing at the dock to be serviced by a full staff. (Both, HM.)

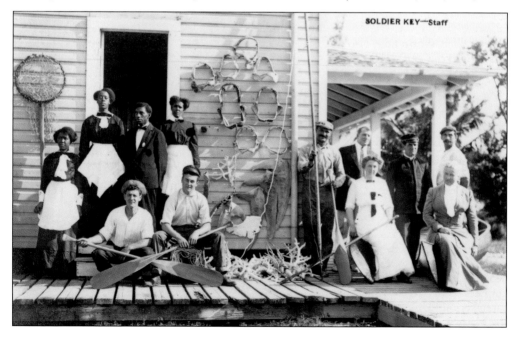

SOLDIER KEY—Staff

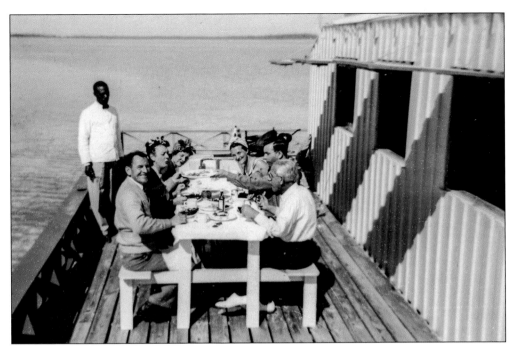

On the Biscayne Flats south of Key Biscayne, starting in the 1920s, barges and boats were rammed onto the shallows to form a community of sorts, initially called "The Shacks." Eddie "Crawfish" Walker, who came from Key West in 1907, built his shack in 1933 to sell lobster-based chowder, bait, and gambling. Others followed. The more substantial Calvert Club, shown here, also was built in the 1930s. (HM.)

During the Depression and smuggling years of 1934 and 1935, Charlotte and Russ Niedhauk lived in a house on the north end of Elliott Key. Charlotte writes of her experiences, including their unanticipated life among rumrunners, in her book *Charlotte's Story*. They departed after the 1935 hurricane but later spent over 20 years as caretakers of Lignumvitae Key for the Matheson family. (MCPL.)

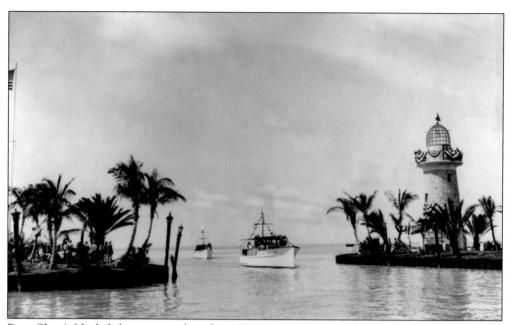

Boca Chita's fake lighthouse created southern Biscayne Bay's most distinctive and iconic landmark. In the 1930s, thermostat inventor Mark C. Honeywell and architect August Geiger made keen use of native limestone rock and concrete to create a private resort where Honeywell and his wife, Olive May, retreated and entertained, attracting the city's—in fact the country's—elite to their island. Boca Chita is now a national historic district. (HM.)

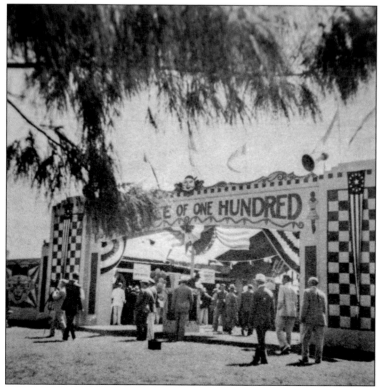

In 1941, the Committee of 100's "Southern Outing" came to Boca Chita. Attending were 700 famous wintering men of Miami Beach and other invited worthies. Boats raced to the island, competing against their predicted times and being greeted by cannon salute. Activities included a water nymph show in the harbor, the boat race awards, the food pavilion, and beyond the midway entrance, shown here, cleverly named activity booths honoring eminent citizens. (HM.)

Booths included Dr. Squibb's Horse Shoe Toss, Bill Welbon's Win Wheel, Cal Bentley's Bouncing Babies baseball toss, and Snite's Saloon. Fred Snite Jr. was famous as the "Man in the Iron Lung," a polio victim who provided inspiration to sufferers worldwide. Shown in front of the booth honoring Fred Snite Sr. are Dr. Cayetano Panettierre, Jack Ferber, Howard McNamara, L.A. Young, and Walter Schulke. (HM.)

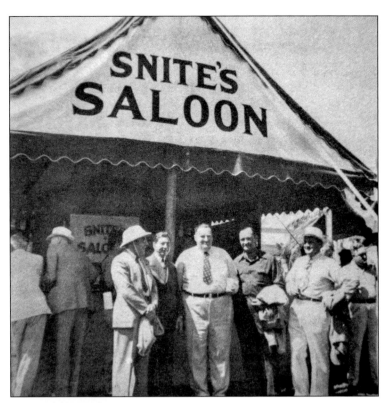

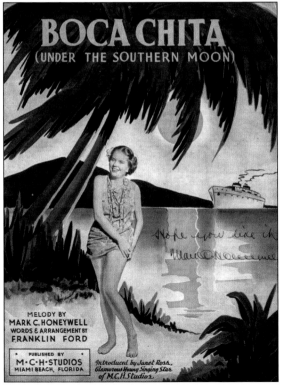

Honeywell memorialized his perceived Boca Chita delights in song: "I'm on my way tonight to Boca Chita where it's always June. My señorita is sailing there with me. The palms are swaying. The waves are playing while I am singing my little tango tune. And so I'll roll along and sing my island song. Boca Chita under the southern moon." After Olive May died, Honeywell seldom returned. (NPS.)

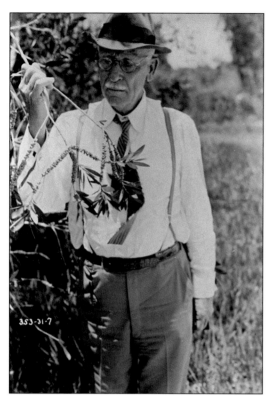

Farther south on Elliott Key, pioneer homesteads were redeveloped. Dr. John Gifford, former and future forestry professor, writer, and banker, bought William D. Albury's plot near eponymous Billy's Point. Gifford subdivided and publicized the virtues of Elliott Key's development, arguing for building a causeway. He was proud to have introduced the melaleuca tree, which he is inspecting here in 1938 and which eventually invaded large portions of South Florida. (CM-HM.)

In the 1920s, Charlie Brookfield bought 20 of Gifford's acres to build the eight-room Ledbury Lodge. Shown a wreck, he convinced Hugh Matheson to help salvage it. Later identified as the HMS *Winchester*, the site produced over 30 cannons, which the amateur salvors distributed widely. Here, Brookfield is sitting on one at Matheson's Lignumvitae Key. Others are at the Biscayne Bay Yacht Club and Boca Chita harbor entrance. (SAF.)

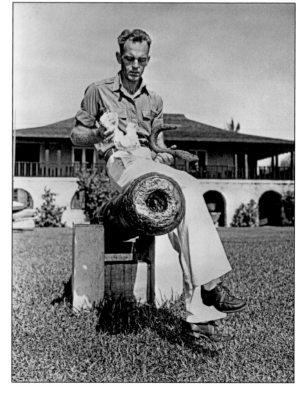

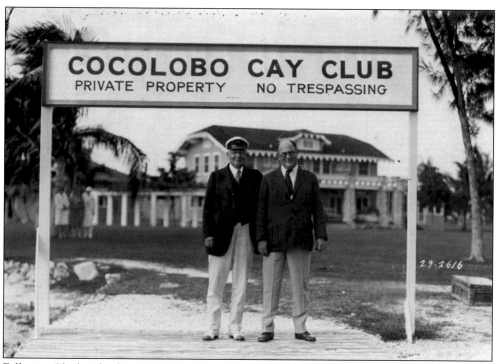

Following Flagler's lead, in 1916 Miami Beach's developer Carl Fisher and partners bought Adams Key, added fill, and built a hotel and casino (bathhouse) that became the Cocolobo Cay Club. Fisher, on the right, entertained prospective Miami Beach buyers and celebrities. It was also a membership club for captains of industry and finance, such as C.W. Chase, T. Coleman DuPont, Harvey Firestone, Gar Wood, and their private guests. (HM.)

One such guest was Warren G. Harding and his friends, including those later implicated in the Teapot Dome scandal. Although a fisherman, Harding mostly appreciated the isolated club atmosphere. Both he and Fisher welcomed photographers so as to publicize their outings. In this 1922 image, President Harding is being counseled by an unidentified fishing guide. (SAF.)

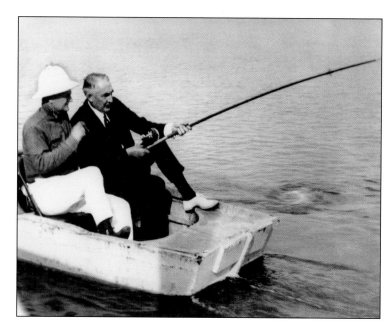

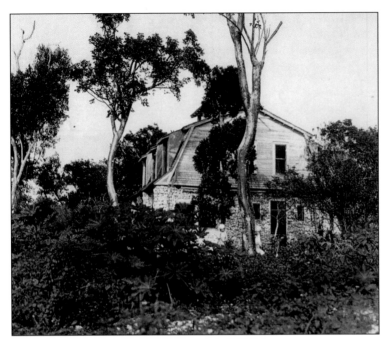

Farther south on northern Key Largo, W.A. Scott built a house as a fishing camp and trading post, shown here in 1912. In the 1930s, Cities Service Corporation's Henry Doherty established the camp as a destination for guests of Biltmore and Roney Plaza hotels, part of his Florida Year Round Club. Special guests could arrive by Auto-Gyro, an airplane-helicopter hybrid, or a luxury trailer, the Aerocar. (KLAC.)

Starting in 1946, new owners expanded the camp into the rustic but elegant Key Largo Anglers Club, providing access to Card Sound, Biscayne Bay's southern extension. Former president and expert bonefisherman Herbert Hoover fished there for many years late in life. This 1958 image shows, from left to right, granddaughter Margaret Hoover, son Alan, guide Slim Pinder, Bunny Miller, the president's guide and friend Calvin Albury, the former president, and Larry Richey. (HHPL.)

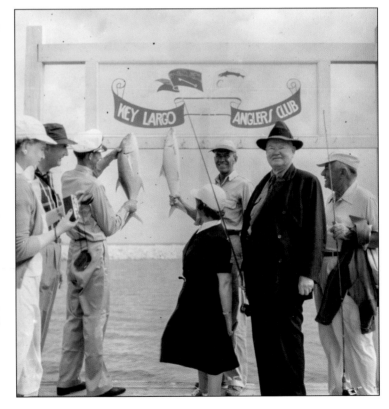

Another early north Key Largo fishing lodge from which fishermen accessed nearby waters was the Dispatch Creek Fishing Camp. Purchasing the camp in 1945, Morris and Alice Baker turned it into a small fishing marina. But by the mid-1950s, the Bakers had increased their holdings to about 1,300 acres and began the process of adding homesites, a golf course, and an airport, creating the beginnings of Ocean Reef. (ORC.)

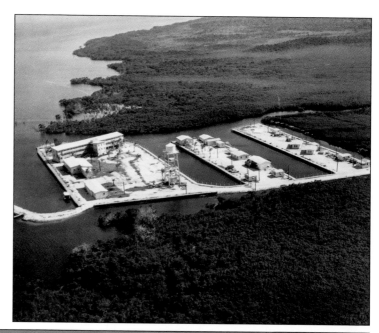

One of Ocean Reef's innovations was the yachtel, designed as a modest cabin to provide land-based lodging for boaters. Ocean Reef's marina, homesites, and hotel catered to those wanting the area's prime attractions—boating, fishing, and getting away. Visitors and residents fished the bay, reef, and deep waters outside. Ocean Reef Club became famous for providing opportunities to catch big fish. (ORC.)

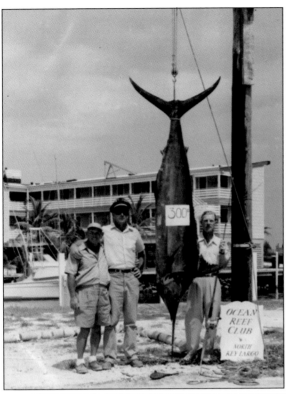

The club's fishing guides were widely known. In the 1950s, Don Bower and Alan Self, fishing the "inside," and Tommy Gifford fishing the "outside," put Ocean Reef Club on the international map. Gifford, shown here at left with Holly Hollenbeck and Ben Atherton, is credited with developing the outrigger for trolling baits, kite fishing, and light tackle big-game fishing. In the shallows, bonefish were a prime target. (ORC.)

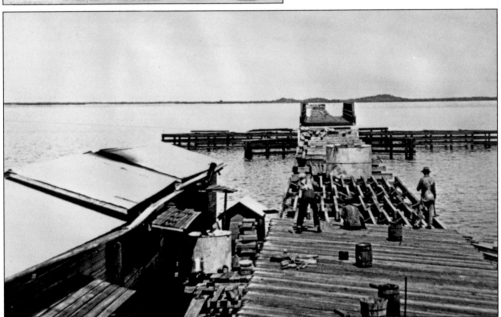

Unlike Elliott Key, neighboring Key Largo was connected to the mainland by a road. The first bridge across Card Sound, shown being built, was constructed in 1926 as part of the Overseas Highway. The road encouraged development on the key and opened Card and Barnes Sounds. The bridge was removed in the mid-1940s after fire, hurricanes, and opening of the new highway following the Flagler railroad alignment. (SAF.)

Three

ERA OF DEVELOPMENT

After World War II, the population of South Florida blossomed, producing new homeowners and increasing numbers of powerboaters. Leisure time, disposable income, and sunny weekends were available for outdoor activities, such as boating, fishing, and the developing sports of skin and scuba diving. Boaters made use of new county park facilities near Homestead and on Elliott Key or visited establishments at Stiltsville. The rich and powerful continued using their getaways, and others continued to live on the islands. Charitable undertakings were established. Owners began banding together through such groups as the Elliott Key Improvement Association. Also eyeing the southern bay area were those interested in its large-scale development. In 1950, Dade County launched a serious proposal to build a causeway from Key Biscayne to Key Largo, which would have dredged and filled its way down the Biscayne Flats and the southern bay islands. This proposal brought southern Biscayne Bay to the attention of South Florida's development frenzy and those who opposed it. Although that causeway plan died, there emerged other proposals for causeways, a deepwater seaport, oil refinery, power station, rocket engine plant, and for the development of the southern bay keys into another Miami Beach. Thirteen landowners, some hoping to protect their island homes and others committed to a causeway and development, incorporated a town encompassing the southern bay's islands. On nearby northern Key Largo, access was made easier by reopening the Card Sound Road. Industrial development on the mainland called for a deepwater channel through the shallows, between the islands and through the coral reef. One of the first realized threats to southern Biscayne Bay was the impact on seagrass beds of Turkey Point Power Plant's heated discharge. The Biscayne Bay Conservation Association formed in 1953. By the 1960s, significant public engagement, led by the Izaac Walton League, Tropical Audubon Society, and the Safe Progress Association, had materialized for governmental protection of southern Biscayne Bay, northern Key Largo, offshore waters, and the northern reef tract. Politicians began to be persuaded that much of the area should be safeguarded as parks.

Perhaps no place illustrated the public's perception of the bay of the 1950s and 1960s better than the shacks, beached barges, and grounded boats on the Biscayne Flats. Structures came and went with numbers peaking at 27 in the early 1960s. Originally a gaming establishment, the Quarterdeck Yacht Club (shown here) achieved elite status when featured in a 1941 *Life* magazine article that calls Stiltsville an extraordinary American community dedicated solely to sunlight, saltwater, and the well-being of the human spirit. And residents enjoyed other activities too; Harry Churchville's Bikini Club offered a clothes-optional sundeck and free drinks to bikini-clad women. It was closed down for not actually having a liquor license. The Miami Springs Power Boat Club started its clubhouse on a sunken barge in the 1950s before building a stilt house after Hurricane Betsy in 1965. New building codes required a 10-foot elevation, thus solidifying the Stiltsville name. Stiltsville became a must-see tourist destination. The fates of the structures were eventually determined by fires and hurricanes, starting with Hurricane King in 1950. In 1992, Hurricane Andrew left seven. (JN.)

In the 1950s, one famous house was that of Jimmy Ellenburg (right), owner of Jimmy's Hurricane Restaurant, who entertained the rich and famous in both places. One guest was Gov. Leroy Collins (left), who created a scrapbook for Ellenberg in which he wrote: "When the time comes when I say so long to this life I hope the great beyond seems a lot like your cabin in the sea." (HM.)

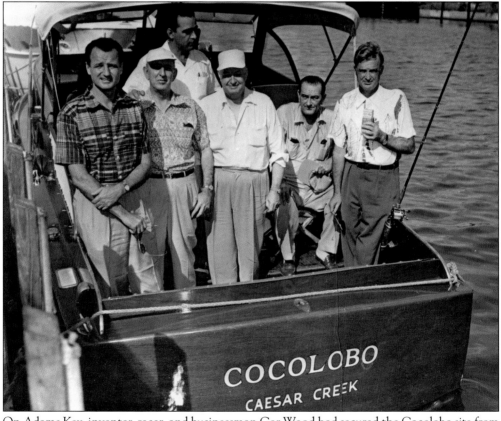

On Adams Key, inventor, racer, and businessman Gar Wood had secured the Cocolobo site from Carl Fisher and in 1954 sold it to Key Biscayne banker Bebe Rebozo and partners. Their Cocolobo Fishing Club continued to entertain the rich and powerful, demonstrated in this 1958 image of powerhouse senators George Smathers, Richard Russell, Earle Clements, Lyndon Johnson, and Stuart Symington. Rebozo is behind. The unseen captain is Lancelot Jones. (SAF.)

Local television personality Jim Dooley cofounded the Jim Dooley Fishing Club on Elliott Key with Miami police chief Bill Norton. Starting with a surplus yacht, a dozen boys, and 30 cleared acres on the key, the youth camp grew astoundingly to over 16,000 members. From the 1950s to the 1960s, the camp was free to youth, funded by commercial sponsors of the daily *Jim Dooley Show.* (HM-MNC.)

On Elliott Key in 1956, Capt. Andre "Andy" Mathieu cleared over 90 acres of land to create Camp Recovery, an alcohol rehabilitation center. The camp provided a structured work environment for recovering men. It persisted for nine years, eventually closing for lack of money. Captain Mathieu also formed the Algo (alcohol-go) Boat Club for boaters with alcohol problems, perhaps something needed today. (HM-MNC.)

Israel Lafayette Jones turned over the family plantation and its home (shown here) to his sons in 1929. Lancelot and Arthur Jones, the "Lime Kings," continued selling limes locally, but by the late 1930s, they gave up large-scale farming in favor of providing fishing and guiding services, particularly to guests at the nearby Cocolobo Club. Lance became a well-known local personality from his home on Porgy Key. (JN.)

Not all visitors were powerful politicians but were still influential. The bay and the reefs attracted scientists who conducted numerous basic studies, especially from the University of Miami's new marine lab on Virginia Key. A science popularizer, author Rachel Carson, visited the bay to take her first diving trip in preparation for her book *The Sea Around Us*. This 1952 image shows her inspecting the shallows with Bob Hines. (USFWS.)

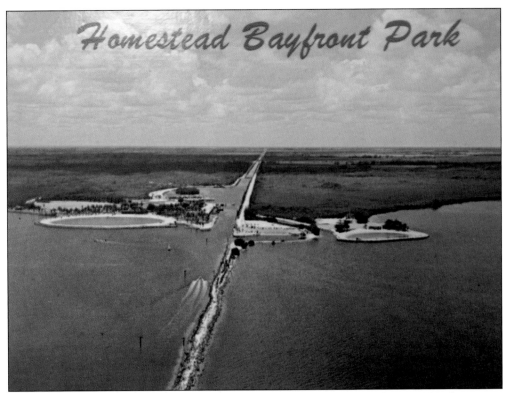

For decades, people accessed the south bay area from Miami or the keys, but in 1939, the county began creating Homestead Bayfront Park at Convoy Point. The military took the site over during World War II, but the park opened in 1955 as a convenient, public, southern access point. To the left of the canal in this image, the park provided boat ramps, a marina, a marked dredged channel, and a swimming lagoon. (NPS.)

Across the canal, to the right in the previous image, Homestead Bayfront Park North was built for the African American population. The park was not quite equal and very separate, having difficult access down a long, police-patrolled rock road. This photograph shows swimming instruction in 1961. The park was closed after the Civil Rights Act of 1964 and the space was turned into a family campground. (HM.)

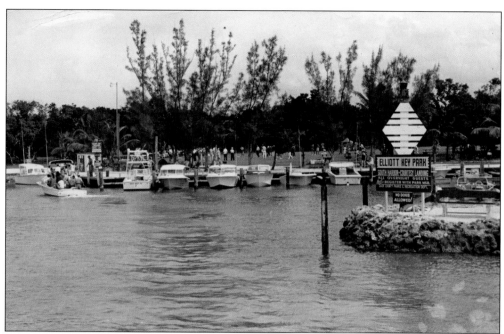

In 1953, Dade County opened another southern Biscayne Bay park, on Elliott Key. The park provided dockage, camping, and access to the interior forests of the island. Elliott Key Park became a well-known and well-appreciated destination for boaters, one of the few publicly accessible landfall sites in the southern bay. (HM-MNC.)

The public was not always welcome. On Elliott Key in the late 1950s and 1960s, Ledbury Lodge, shown, was repurposed by the CIA for training Cuban exiles for what would become the Bay of Pigs invasion. Farther south on Linderman Key, industrialist Bert Linderman's former mansion also was used by the CIA. Nike missile launch and guidance sites were constructed on northern Key Largo—all far from public view. (NPS.)

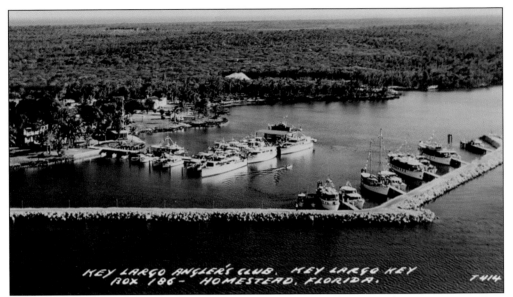

Also on northern Key Largo, the Key Largo Anglers Club continued to quietly care for its members and distinguished guests, boating and fishing Card Sound and the southern bay area. Presidents Eisenhower and Nixon used the club as a getaway. Enduring hurricanes, it transformed into a private membership club, continuing to this day and kept something of an open secret. (JWC.)

Ocean Reef also quietly progressed, the extent of which can be seen in this 1987 image, gaining permanent and wintering residents and hosting celebrities, famously Gov. Claude Kirk and Pres. Richard Nixon, as well as a presidential meeting between George H.W. Bush and France's Francois Mitterrand. As other developments languished, Ocean Reef became an island of development surrounded by undeveloped areas, and the residents effectively led opposition to further southern bay development. (MCPL.)

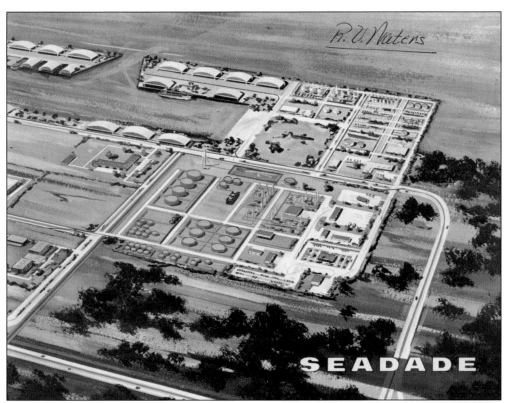

In 1959, Daniel K. Ludwig, one of America's wealthiest persons, announced impending development of 28 square miles of Biscayne Bay shoreline. His intentions eventually were revealed to include a cargo port, 40-foot-deep basin, 30-foot-deep channel, and oil refinery. Initially well received by the government, the Seadade proposal outraged environmentally concerned citizens. Although eventually abandoned, the proposal served to bring conservation of the southern bay to public consciousness. (HM-RVW.)

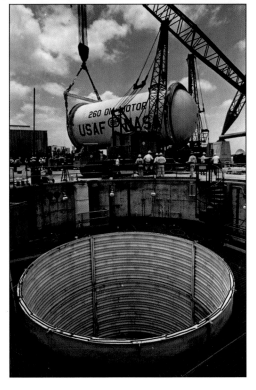

Another industrial project was the Aerojet solid-fuel rocket engine manufacturing and testing facility. The Aerojet Canal (C111) was dug from Manatee Bay to transport engines. Its levee altered coastal surface hydrology. Flames from a 1965 test were visible in Miami; a 1967 test sprayed acid onto Homestead. The program ended in 1969. The 180-foot-deep test silo remains, buried, with an engine still inside. (HM-MNC.)

45

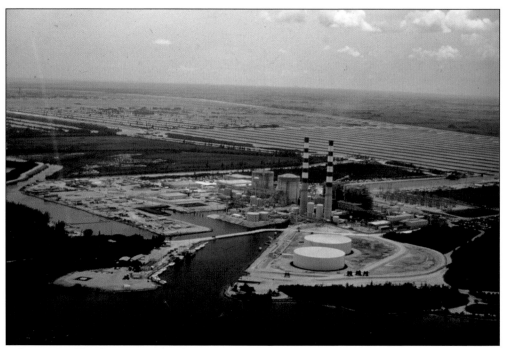

In late 1960s, Florida Power and Light Company (FPL) completed two oil-fueled electric generating plants on the bay's edge. When their heated cooling water discharged into the bay, it stressed the adjacent seagrass community. FPL's solution was to dig a 20-square-mile cooling canal system (upper portion of the image). Two nuclear plants followed. The Turkey Point Nuclear Generating Station became the country's sixth-largest power plant. (NPS.)

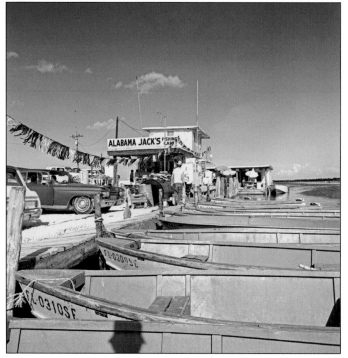

With failure of other causeway proposals, in 1969 funds were made available to renew the Card Sound Road and bridge. In the meantime, the Card Sound fishing village had come to occupy the roadbed with shacks, boat docks, 100 residents, and rendezvous restaurants, such as Fred's Place and Alabama Jack's. The road increased access and inspired conservationists to save the habitat on northern Key Largo. (SAF.)

In 1961, thirteen landowners voted to create the city of Islandia in the southern bay. This image shows their voting booth on a pickup truck. In front are, from left to right, Howard Bouterse, Ralph Fossey, Mayor Luther Brooks, Fred Belland, unidentified, and Jean Belland. Other property owners were less enthused about incorporation. That landowners, not residents, voted to incorporate was a reason why the city was abolished in 2012. (JN.)

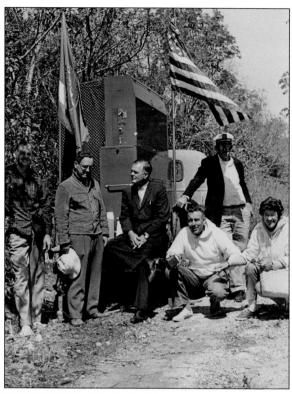

Among Elliott Keys owners were Coconut Grove's John and Jane Nordt (left and center with son John III), who constructed a house in 1962 just north of Adams Key. Jane's father had come to Miami in 1912, sold real estate with Carl Fisher, and first bought land on Elliott Key in 1925. The part-time island retreat was called Sandwich Harbour, in honor of the bay's old name. (JN.)

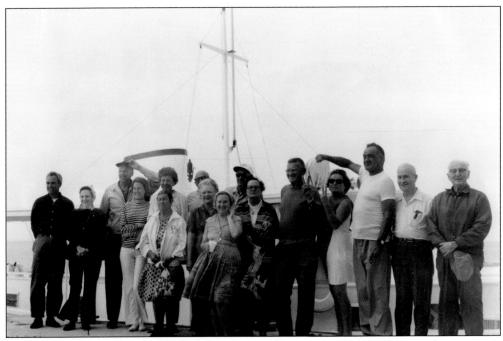

This 1970 image shows some of the town's principals. From left to right are unidentified, Mrs. William Martin, John C. Nordt, Mrs. Jack Pyms, Jean Belland, Alice Sweeting, Capt. Elliott Park, Mrs. David Hall, Mrs. Elliott Park, Howard Bouterse, Mrs. William Gorman, Abner Sweeting, Jane Nordt, unidentified, David Hall, and Reg Waters, all standing in front of Captain Park's yacht *Eloise*. (HM.)

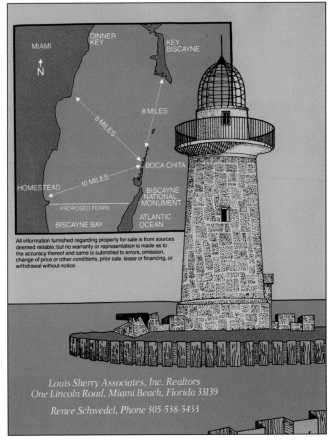

All information furnished regarding property for sale is from sources deemed reliable; but no warranty or representation is made as to the accuracy thereof and same is submitted to errors, omission, change of price or other conditions, prior sale, lease or financing, or withdrawal without notice.

Louis Sherry Associates, Inc. Realtors
One Lincoln Road, Miami Beach, Florida 33139

Renee Schwedel, Phone 305-538-5433

The town fathers conducted a long and persistent battle to develop their lands. Plans included dredging and filling, subdivisions, high-end homes, resorts, and, of course, a causeway to Black Point or Key Largo. This representative sales pamphlet places Boca Chita at the apex of a future golden triangle formed with the "next great urban centers" of Homestead and South Dade. (HM.)

With Islandia lacking land connection, one got there by boat. The Islandia Ferry operated between Homestead Bayfront Park and Elliott Key County Park, bringing day-trippers, campers, and owners to the key. Once one was on the island, available ground transportation included a Volkswagen van, shown in the 1968 photograph below. The fee for a ride from Sands Cut to Caesar Creek along the narrow Elliott Key Boulevard was 25¢. (Right, JN; below, HM.)

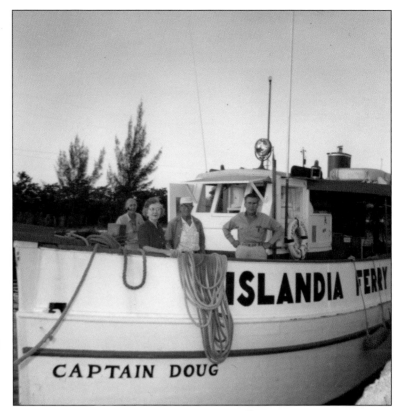

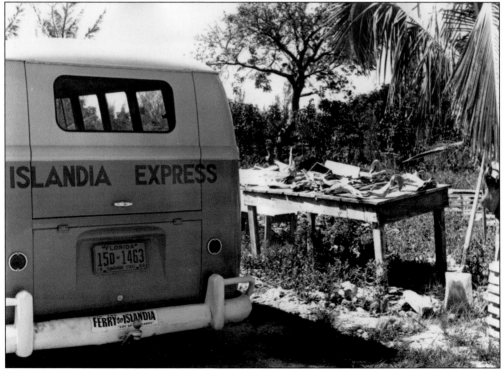

Opposing development was a gathering force of conservationists and eventually crucial public officials. Leaders of the citizen's campaign included Lloyd Miller, who founded the Safe Progress Association for the purpose, and businessman Herbert Hoover Jr., who lent his financial support and political connections. Shown here are author Philip Wylie (left) and attorney, later US attorney general, Janet Reno (below). Other pro-monument activists included Joe Browder, Ed Corlett, Dave Davenport, Juanita Greene, Lain Guthrie, Carl Karman, Bill Lazarus, Charles Leffler, county commissioner R. Hardy Matheson, Al Pflueger Sr., Jim Redford, Polly Redford, and Belle Scheffel. The southern bay area became a public cause against hugely resistant forces in favor of economic development of the area. (Both, SAF.)

One of the great breakthroughs was the conversion of pro-development Gov. Claude Kirk (above), who upon winning his election took an off-the-grid sailing vacation out of Ocean Reef with his fiancée, Erika Mattfeld, whom Kirk mischievously liked to refer to as "Madame X." His environmental advisor, Nathaniel Reed (below), made sure that a well-briefed and committed marine patrol officer went with the couple to help pilot. It was also his job to convince Kirk of the value of making the area a park. While they awaited the incoming tide to refloat their grounded sailboat, he accomplished the goal. Kirk led the state's side of the effort to protect the bay, including denying requests for dredging and causeway permits and then turning over state-owned bay bottom to the federal government for the monument. (Both, SAF.)

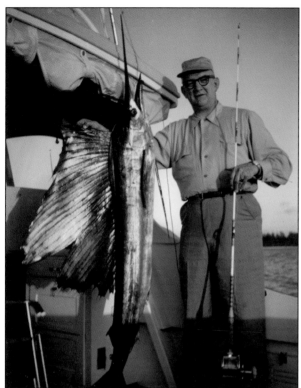

A similar story, one encouraging federal support, came about when Jim Redford took Congressman John Saylor fishing, hooking him up with a sailfish. Saylor was brought back into the bay so he could be photographed near Boca Chita Lighthouse, in what would be the monument. The congressman was assured that such fish were plentiful in the future monument, with the experience securing influential support for the bill. (NPS.)

Backers of Islandia, including Bebe Rebozo on Adams Key, were understandably fierce opponents of the national monument plan. To discourage Congress as the bill was being drafted, in February 1968 Luther Brooks and others floated a bulldozer to Elliott Key and enlarged the then relatively innocuous trail, Elliott Key Boulevard, into a 125-foot-wide clear-cut roadway down the island's forested backbone. The elongated scar became known as Spite Highway. (NPS.)

Four

BISCAYNE NATIONAL PARK

In 1968, Pres. Lyndon Johnson signed a bill establishing Biscayne National Monument, speaking from his personal experience of the resources now being protected. The National Park Service took on responsibility for the new monument, buying land, slowly accumulating budget and staff, repurposing facilities, and starting management operations. In 1974, the monument's area was increased, and an easement through Broad Creek, which had been exempted to allow for a commercial shipping channel, was eliminated. In 1980, the monument was redesignated as Biscayne National Park and was again expanded to include much of central Biscayne Bay, nearly up to the Cape Florida channel off Key Biscayne. The expansion included the islands from Boca Chita to Soldier Key, the world-famous bonefishing flats surrounding them, and Stiltsville. The bonefish flats were among a primary reason to go so far north. The inclusion of Stiltsville was more problematic, as were continuing complexities with shared fisheries management between the state and federal governments. In 1984, the central and southern bay was declared a spiny lobster sanctuary to protect juveniles in their nursery grounds. The Legare Anchorage off Sands Key was declared off-limits to protect the HMS *Fowey* wreck site. Sportfishing and some commercial fishing continued, increasingly joined by powerboaters, sailors, divers, birders, nature lovers, and weekend partiers.

In 1992, Hurricane Andrew, making its landfall on Elliott Key, rearranged things markedly. It destroyed historic structures and leveled vegetation. Post-hurricane, the park reemerged slowly, improving its infrastructure. Surviving Stiltsville structures and the Fowey Rocks Light came to park ownership. The park obtained coastal mangroves along its edge on the mainland, creating a buffer. With the local population increasing, more and more boaters discovered the park as a place to go on weekends or on holidays. Approaching 50 years old at the time of this writing, the park's story has matched the time spans of the pioneer days and of Islandia.

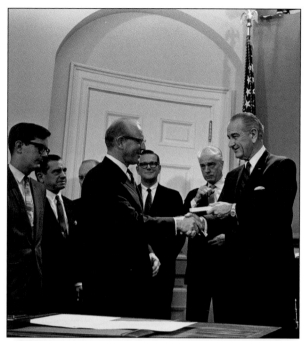

President Johnson, who had boated the area many years before, signed the bill creating the monument on October 18, 1968. Shown are, from left to right, Audubon representative Joe Browder, Miami congressman Dante Fascell, monument advocate Lloyd Miller, county commissioner and Islandia landowner R. Hardy Matheson, county mayor Chuck Hall, and Johnson. (LBJPL.)

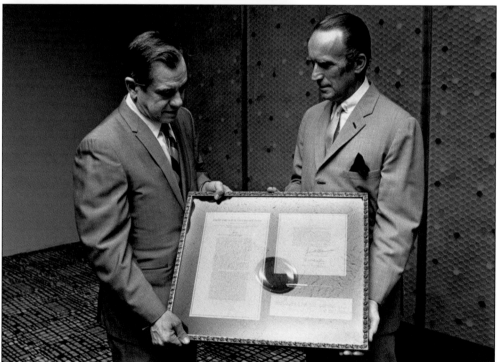

Congressman Dante Fascell was the monument bill's chief sponsor; its visitor center is now named for him. A crucial monument advocate was Herbert Hoover Jr., president of the vacuum cleaner company. Having a lifelong fondness for the bay, Hoover used his influence to encourage the monument movement. Here, Fascell (left) acknowledges Hoover (right) with a framed copy of the bill. Hoover also established a foundation supporting science-based marine conservation. (HM.)

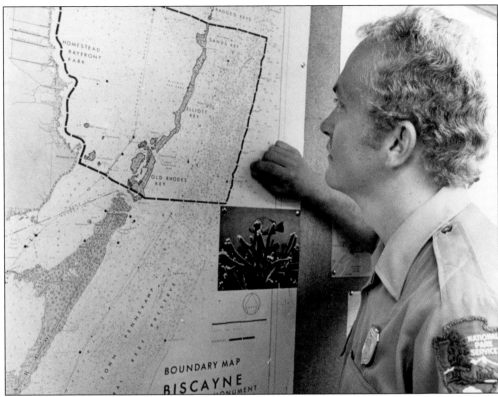

In April 1971, Biscayne National Monument received its first superintendent, Dale Engquist, shown posing in front of a map of the new monument. Among his few staff were rangers George Sites and Don Weir and Howard Bouterse, former Cocolobo Club caretaker (and Bebe Rebozo's brother-in-law). In the early years, the few staff members did most everything. (GK-HM.)

The State of Florida made its second large transfer of the bay bottom to the federal government in 1985. This photograph shows Gov. Bob Graham on Elliott Key signing the transfer papers, thereby enlarging the national park. The transfer also included the leases for the remaining Stiltsville structures. (NPS.)

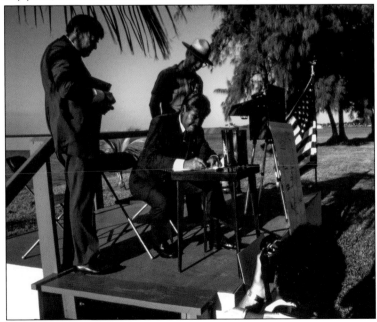

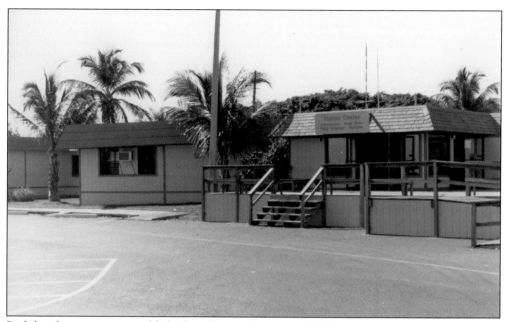

Park headquarters was established at Convoy Point, on the location of the campground and long-closed segregated county park. For many years, this complex consisted of repurposed and temporary buildings. This late 1980s image shows, from left to right, structures for lab and storage, resource management, and the visitor center. (NPS.)

Across the North Canal, Homestead Bayfront Park continued to provide access to the monument. Watching the boat launch and retrieval activities at the Homestead Bayfront Park boat ramp became something of a pastime in itself, as not all attempts were without mishap. It also retained its atoll "pool," marina, and other facilities. (NPS.)

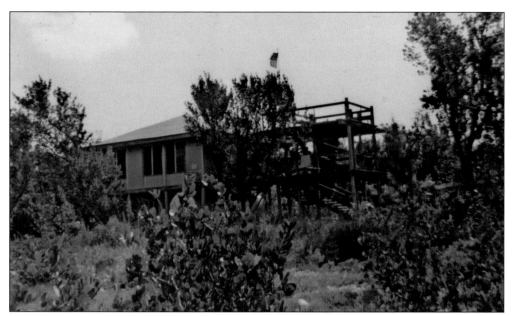

Most homes, structures, and cisterns of the former owners, such as the Nordt residence on Elliott Key shown in this image, were removed by the park or destroyed by hurricanes. Their sites were left to be reclaimed by native vegetation, restoring the forest cover. (JN.)

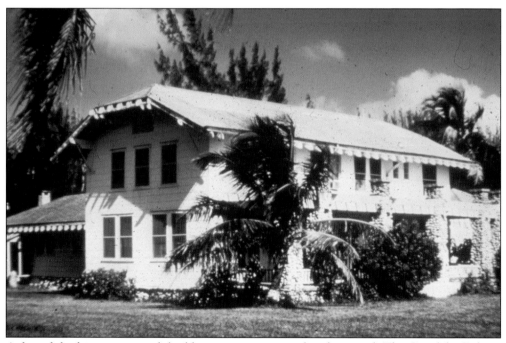

A few of the historic pre-park buildings were repurposed and restored. The Cocolobo Fishing Club buildings became a visitor contact station, park housing, and a home to environmental education programs. However, the clubhouse burned down in 1974, and the casino and caretaker's residence were destroyed by Hurricane Andrew in 1992. New structures were built to provide a ranger station. (NPS.)

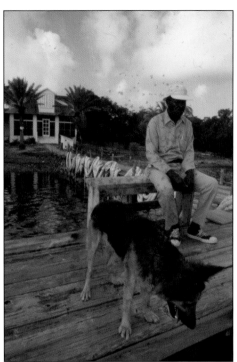

Lancelot Jones and his brother's widow, Kathleen, sold their land to the monument with Lance being granted a life tenancy. He became a fixture in the park as he welcomed visiting boaters, told stories of old times, and gave his sponge talk to students at the ranger station. Although his family home burned in 1982, he continued living in a smaller house nearby, until he was evacuated as Hurricane Andrew neared in 1992. (TC-HM.)

The other two island residents, Virginia and Hall Tannehill, also secured life tenancy. Virginia lived in her house, built in part from salvage of the *Mandalay*, on Elliott Key until it was demolished by Hurricane Andrew. She was a well-known and indefatigable beachcomber, bottle collector, and island explorer. Once, she found Spanish silver coins from the 1600s along the beach, likely the key's only "treasure" find. (NPS.)

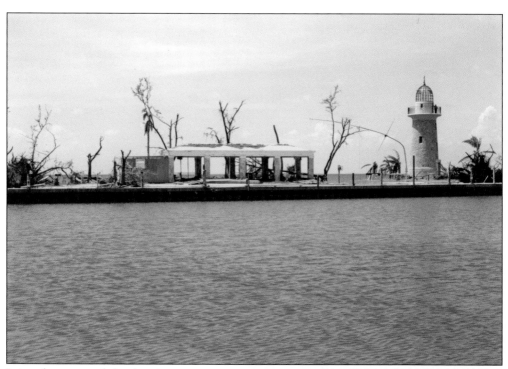

It is to be expected that hurricanes periodically hit South Florida. In 1992, Hurricane Andrew made landfall in southern Biscayne Bay as a Category 5 hurricane, destroying much of the park's infrastructure, including the remaining Cocolobo Club structures, houses, and park buildings. This image is from Boca Chita Key. Hurricane Andrew also ravished vegetation, affecting rare species, but native vegetation and the marine environment recovered in a few years. (NPS.)

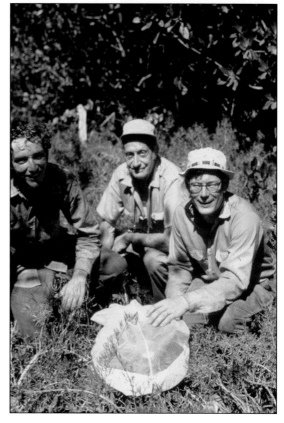

Rare species, however, are at risk from storm events. Limited to South Florida in the United States, Schaus's swallowtail butterfly depends on a few host plant species in the limited habitat of tropical hammocks. Entomologists George Rawson (center) and Charles Covell (right) surveyed extensively in the early 1970s, rediscovering the park's populations. In 1984, Schaus's swallowtail became the first federally listed invertebrate. The park continues to support vital populations. (NPS.)

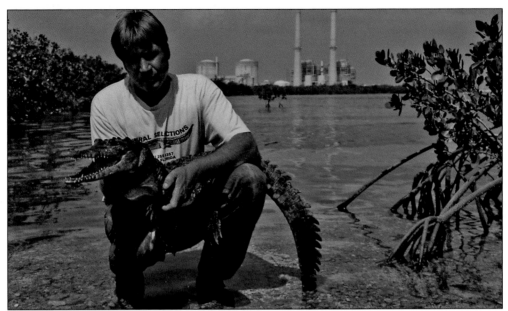

An unexpected benefit of Florida Power and Light's Turkey Point cooling canals was their colonization by endangered American crocodiles. The canals, establishment of the Crocodile Lake National Wildlife Refuge on northern Key Largo, and other protections led to the population's recovery in South Florida in the past several decades. Shown here is biologist Joe Wasilewski with a crocodile captured as part of FPL's long-term monitoring program. (JW.)

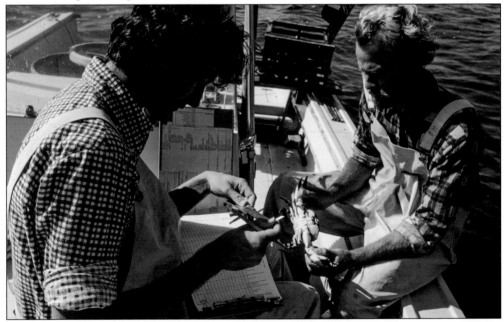

Research and monitoring of the park's resources are essential to management. From the mid-1970s to the mid-1980s, coauthor Jim Kushlan conducted wildlife and endangered species studies in the monument. This 1978 image shows Don McArthur and Jim Chapman measuring a stone crab. Commercial fishing in a national park is atypical, and the stone crab fishery has unusual regulations. Stone crabs are trapped, legal-size claws removed, and the crab released. (NPS.)

As data show and any longtime South Florida angler or diver will confirm, fish stocks, both harvested and non-harvested, have declined over the decades. Changes in the reef, grass beds, water chemistry, pollution, spawning conditions, and harvest contribute to this decline. Hook and line fishing by commercial and recreational fishermen account for nearly all the take of fish, many of which have state-mandated limits regarding size or number that can be taken. (NPS.)

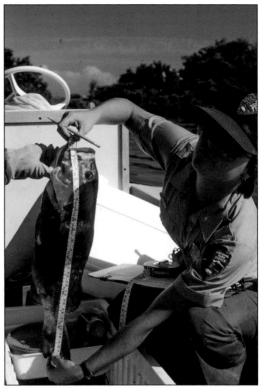

Bonefishing has attracted anglers to southern Biscayne Bay for a century. The northern Biscayne Flats are known worldwide for their large bonefish. Bonefish are schooling, bottom-foraging fish, usually seen "tailing" (rooting in the sand with tails up) or "mudding" (digging up the sediment). They are powerful runners when hooked. Although bonefishing is now restricted to catch-and-release, this was not always the case, as shown in this 1976 photograph. (NPS.)

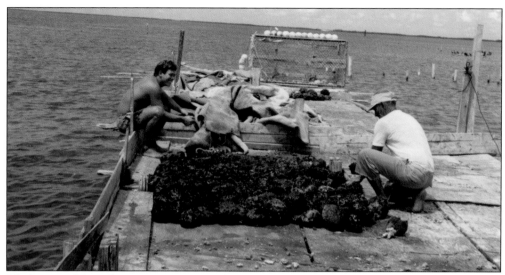

The historic fishery for sponges was revived in the 1960s and continued into the 1990s, especially by Cuban refugee fishermen. Meanwhile, research was revealing that sponges play a critical role in the bay's ecosystem, much as oysters do in Chesapeake Bay, by filtering large quantities of water. Harvesting sponges ended in 1992, although poaching did continue. This image shows the sponge-drying racks that were located on Pelican Bank. (NPS.)

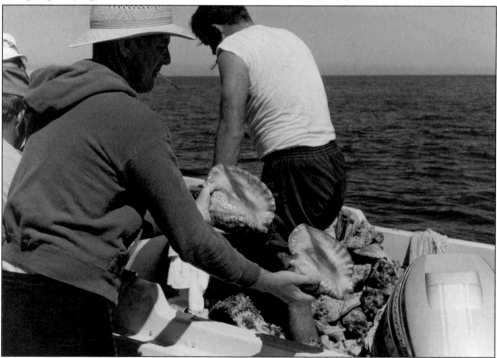

Queen conchs were once common in the bay's grass beds, as they are in the Bahamas today. The archaeological shell midden on Sands Key attests to their historic numbers and availability. Until the 1970s, conch populations supported a fishery for the curio trade, shown here. Conchs are rare and protected today. Those in the bay do not reproduce, although those offshore are able to. (NPS.)

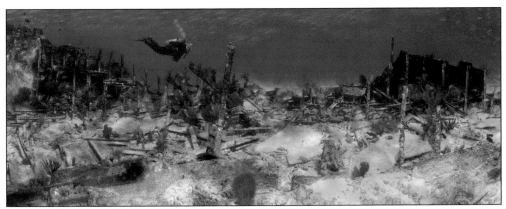

The National Park Service has overseen a commendable inventory of its underwater archeology. Shown is a view of the *Mandalay*, which sank in 1966. This site is part of a national historic area and the park's underwater Maritime Heritage Trail. The centuries of shipwrecks on Florida's reef changed the fortunes of people and countries and now constitute one of the important historical touchpoints of the park. (BS-NPS.)

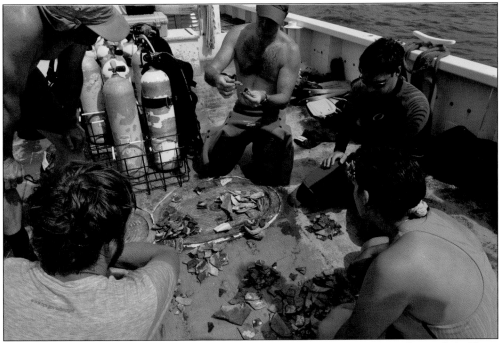

Some information about various wreck sites remains undetermined, such as the English China Wreck, named for the number of ceramics found. The ceramics, being examined by archeologists Charles Lawson (top right), David Morgan (center), and students from George Washington University and South Africa in 2011, prove that the wreck is from the 1760s, but the ship's origin remains unknown. Important historical information continues to be gathered through professional archeology. (NPS.)

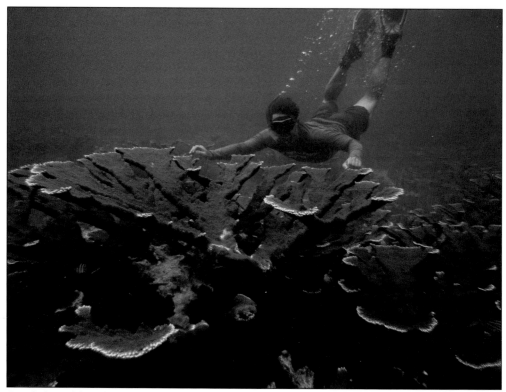

Snorkeling (above) and scuba diving (below) are two visitor activities that blossomed with improved equipment and improved access to the water through personal boats and professional dive operations. Patch reefs are popular locations for both, whereas the deeper reef tract and wreck sites are more accessible to scuba divers. Divers can observe hard and soft corals, reef fish, wrecks, and wildlife, and may spear fish and lobster in the ocean beyond the outer edge of the keys. Many of the reefs have changed markedly in 50 years due to abuse, storms, disease, and high water temperatures. One of the more obvious changes is the loss of branching corals that once covered the reef crest. The magnificent elkhorn coral patch shown above died during the hot summers of 2014 and 2015. (Both, NPS.)

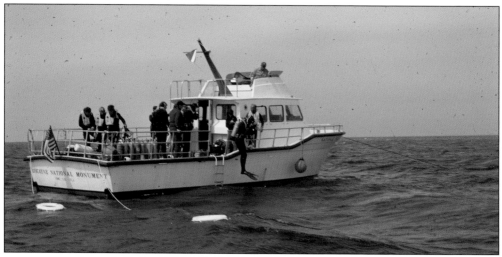

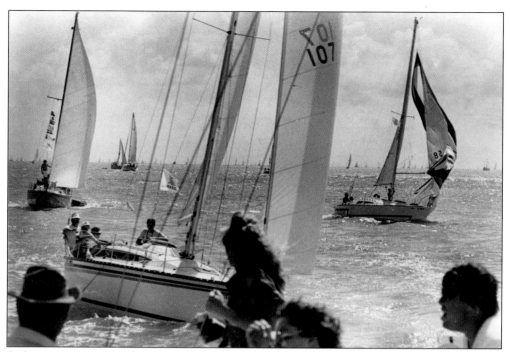

Sailing regattas are anchored in the traditions of the earliest days of Miami's settlement, the first being held in 1887 off Coconut Grove under the management of Ralph Munroe and Kirk Munroe, which led to the founding of the Biscayne Bay Yacht Club. A worthy successor, the annual Columbus Day Regatta started in 1955 (above). Participation has exceeded 700 boats, running down bay one day and back to Miami the next. Derived from the tradition of the regatta overnighting in the southern bay, the area off University Dock and Sands Cut came to provide a rendezvous location for a Columbus Day party. As the course was altered to not come into the park, the party became disjointed from the regatta itself but persisted (below). Hundreds of boats anchor and raft as an excuse for barely constrained partying. (Above, HM-MNC; below, NPS.)

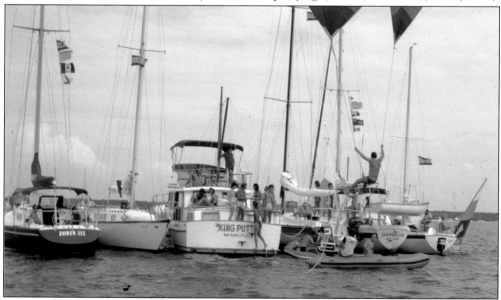

Not all boat trips end well. This sunken powerboat is being aided by a National Park Service boat. Patrolling to assure safe boating remains a challenge to both state and federal officers. But with 95 percent of the park's 173,000 acres being water, much of it shallow and tidally variable, boating mishaps are bound to happen. (NPS.)

Southern Biscayne Bay has long been a smuggler's haven. Guns were run leading up to the Spanish-American War, then alcohol during Prohibition, marijuana in the 1970s, and later cocaine. Large seizures made the news. Also, during all decades, people were sneaking in and out. This 1984 image shows Rick Childs taking inventory of bales containing 805 pounds of marijuana, which were discovered in a 28-foot speedboat drifting off Sands Key. (NPS.)

Yellowstone National Park has grizzly bears and wolves; Biscayne National Park has mosquitoes and sand flies, locally called no-see-ums. Pioneer families lived engulfed in clouds of mosquito-defying smoke, stayed inside, battened windows, and covered themselves almost completely if they had to venture outside. Mosquitoes remain, especially in summer on land, but specialized clothing and repellents have made life easier for park visitors and rangers on the keys, way beyond what the pioneers could have dreamed. (NPS.)

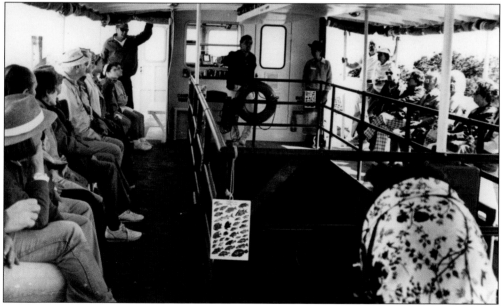

Tour boats operating in the park provide access to remote islands and interpretation of underwater and above-water sights. For many years, glass-bottom boats provided opportunities to see under water without getting wet. For visitors without access to a private boat, these trips provide entry to sites farther afield and educational opportunities. (NPS.)

Interpretation of the park and its resources may take many forms. In this image from 1980, a group of students is being shown the underwater environment at the Elliott Key swimming area. Such opportunities are often a child's first experience with the marine environment. (NPS.)

Biscayne National Park sponsors special events and activities for visitors, such as a Family Fun Fest, in its 17th season at this writing. This image shows Megan Davenport (left) and Gary Bremen in 2016 ready for a park program celebrating the National Park Service's 100th anniversary. The year 2018 marks Biscayne National Park's own milestone— its 50th anniversary. (AT-NPS.)

Five

BISCAYNE TODAY

With the human population of the mainland increasing to levels nearly unimaginable a few decades ago, Biscayne Bay and Biscayne National Park become even more important assets to the South Florida community. As one of the several remaining great natural areas in South Florida, Biscayne National Park provides exceptional values to the human community—environmental, cultural, and social. The national park continues to enjoy the visitation of sailors, powerboaters, kayakers, recreational and commercial fishermen, divers, naturalists, birders, picnickers, campers, hikers, and others who love the water, cherish nature, want to party, or just hope to get away from the metropolis on the park's doorstep. Boats have become more available to diverse economic groups, and the bay is a place where smaller boats are, in many ways, better than larger ones. Boats and the park are synonymous. Biscayne is a park for boaters.

Biscayne National Park continues to protect native, rare, endangered, temperate, and tropical species of plants and animals, some of which are found nowhere else in North America and few other places in the world. Where else in North America but South Florida would one find corals and Caribbean reef fish, spiny lobsters and stone crabs, crocodiles and sea turtles, manatees and dolphins, mangroves and West Indian forest, osprey, black-billed cuckoos, and wintering endangered piping plovers? And all are within a short ride from a boat ramp. Biscayne Bay, the keys, the offshore waters, and the reefs are where South Floridians can come to get away and to renew or, being near Miami, to party if they choose. As the years have passed, the evidence of shipwrecks on the reef and of the community of plantations and homes on the keys are slowly being reclaimed by nature, making the remaining monuments to the past even more precious. The natural environment protected within Biscayne National Park for 50 years remains for the use and enjoyment of this and future generations. To celebrate the park's legacy, this chapter provides a visual journey through the treasures and tales that await explorers within Biscayne National Park today.

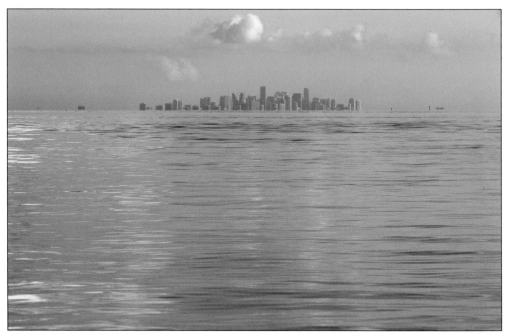

Miami is shimmering on the horizon and floating above the calm waters of Biscayne Bay. The great city of Miami, although experientially a world away, is Biscayne National Park's northern neighbor. The park provides an oasis of nature adjacent to the homes of Miami-Dade County's 2.6 million residents and its over 14 million annual visitors. (KH.)

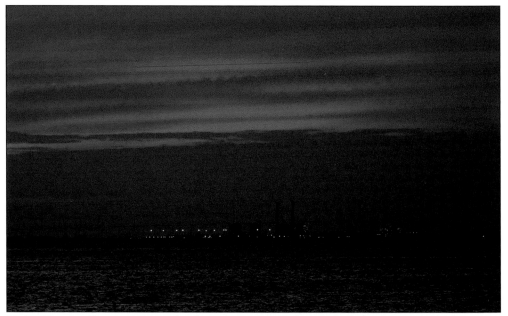

Turkey Point is illuminated at night along the park's southwestern shore. Miami needs electricity, and the park's southern neighbor, the Turkey Point Nuclear Generating Station, provides it. The plant dominates the otherwise low-lying shore of the southern bay by day, by night, and, as shown in this image, at sunset. Yet from Elliott Key anchorage, the plant does appear but a distant intrusion along the bay's still mangrove-lined coast. (KH.)

From within the park, the sun rises beyond Fowey Rocks Light. The historic lighthouse stands about six miles southeast of the even older 1825 Cape Florida Lighthouse, which it replaced in 1878. It also marks the wreck of *Arratoon Apcar*, which plunged into the reef even as the lighthouse was being constructed. Now owned by the park, Fowey's light continues to mark the seaward edge of the Florida reef tract. (KH.)

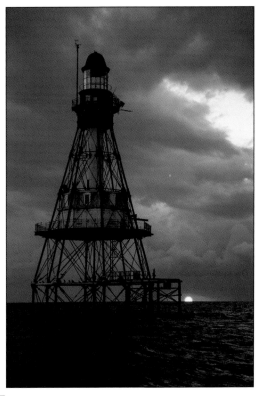

Seabirds find Fowey Rocks Light a convenient roost. The iron-girded structure, although now unused by people, remains well appreciated by seabirds, such as this double-crested cormorant and brown booby. The brown booby is a marine bird that is not often encountered in South Florida nearshore waters, other than when roosting on such offshore structures. (KH.)

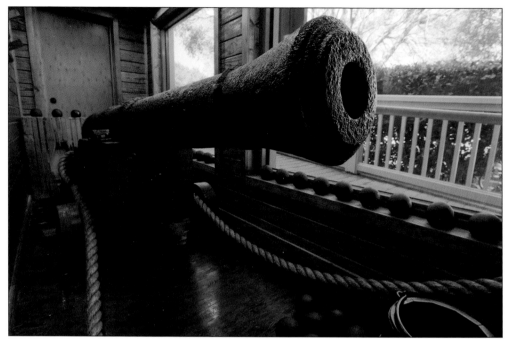

The *Fowey*'s cannons are cherished artifacts. Although Fowey Rocks is named for the HMS *Fowey*, she actually wrecked miles away. One of the *Fowey*'s nine-pound cannons is on display at park headquarters. The cannon's recovery and restoration allowed the wreck to be identified. Unfortunately, illegal and unprofessional scavenging of historic artifacts from wrecks can still be a threat to the historical value of these sites. (KH–NPS.)

The modern Biscayne National Park headquarters is the only park facility on the mainland. It was built after the park's original structures were flattened by Hurricane Andrew. The headquarter complex occupies the site of the historic, segregated Homestead Bayfront Park North. This image shows the park's docks occupying the now-repurposed and mangrove-lined former lagoon. (KH.)

Homestead Bayfront Park at Convoy Point continues to provide boaters access to the southern portions of Biscayne Bay. The long, narrow channel through the nearshore shallows from the point leads boaters to the open water of the bay and from there, typically, to Caesar Creek or Sands Cut, about 7 and 10 miles away, respectively. (KH.)

Summer rains pose challenges and offer experiences to boaters. Rain can be expected almost any time in the park but especially on summer afternoons when skies frequently darken as a gentle shower or fierce squall passes, often quickly. This cruising powerboat continues on its way through the weather off Elliott Key. (KH.)

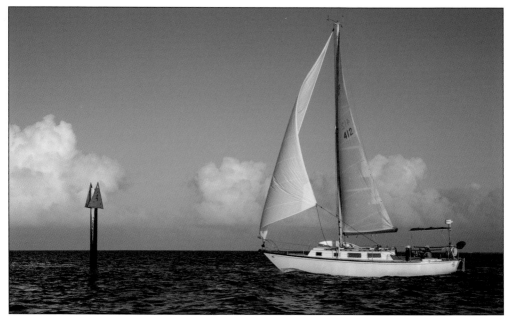

The sailing vessel *Sashay*, with John Sheldon at the helm, sails up the Intracoastal Waterway channel through the Featherbed Banks. The bay's history was built on sailboats, the only means of transportation from the time of its settlement. The bay was home to famous local designs, such as Ralph Munroe's shallow-drafted sharpie- and presto-designed hulls. Twenty-five years prior, Hurricane Andrew deposited *Sashay* on a palm a third of a mile inland. (KH.)

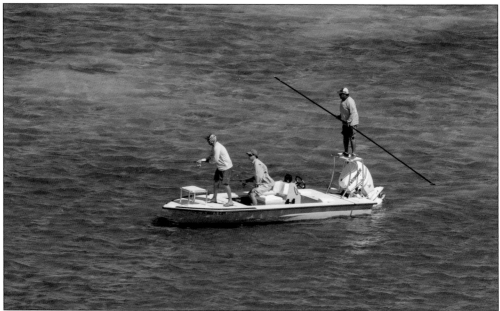

A flats boat being poled along the shallows with a fly-casting fisherman on the bow is an iconic fishing image in the bay. The bay's archetypical powerboat is the small shallow-draft skiff designed to cross the shallows. The extremely shallow-drafted flats boat was created locally in the 1950s by Bob Hewes. From an elevated platform, the boat is pushed ahead quietly while the fisherman casts from the wide deck. (KH.)

Mini season in South Florida is more than another recreational activity. During this annual two-day season, recreationists can catch lobster before commercial fishing opens. Boats mill beyond the lobster reserve boundary awaiting the midnight start. This image shows "bully-netting." The net is placed over a spiny lobster walking the shallows, visible in a light's beam. With 50,000 people participating statewide, mini season is a cherished cultural event. (KH.)

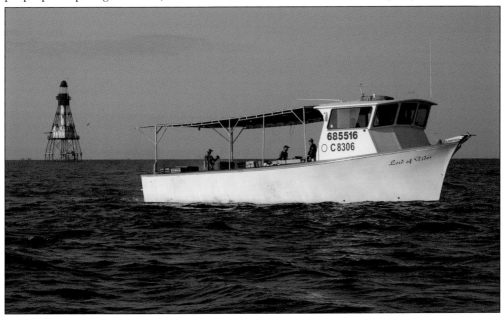

This commercial lobster boat is pulling traps near Fowey Rocks Light, seen in the background. Lobstering is allowed outside the outer shores of the keys, which delimit the bay's lobster sanctuary established to help maintain lobster stocks. Commercial fishing fleets originate at docks, such as at Black Point or on the Miami River, harvesting fish, stone crabs, and shrimp in addition to lobster. (KH.)

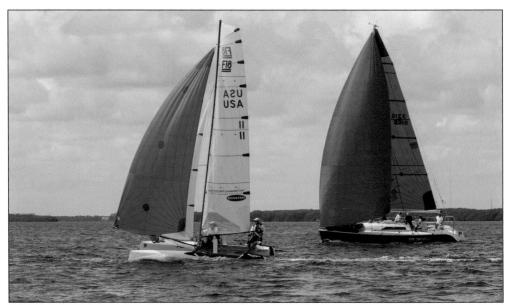

In Biscayne Bay, the tradition of racing sailboats is one of the communities' oldest, dating to when races and a fish-based chowder party were held to commemorate Washington's birthday. Today, the bay is host to dozens of very serious world-class and Olympic sailing events, as well as some not so serious. The Columbus Day Regatta, hosted by the Coral Reef Yacht Club, shown here, remains among the most indigenous. (KH.)

Despite current detachment from the regatta, Columbus Day weekend at Elliott Key continues as a tradition of its own. Attracting hundreds of boats to anchor, raft, and party at the Elliott Key anchorage, festivities feature lots of alcohol, often few clothes, and a fair number of injuries. Yet revelers seem undeterred as they raft up to enjoy a weekend on the bay. (KH.)

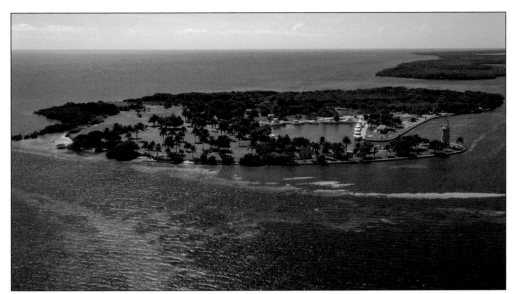

Boca Chita harbor remains a primary boating destination in the park every weekend, for docking, picnicking, camping, birding, exploring, or just hanging out. Structures from the Honeywell era remain to be appreciated as part of this national historic site. Wilson's plovers nest on the island. This view shows the shallow flats, Boca Chita with lighthouse and harbor, and Sands Key beyond. (KH.)

Atop the Boca Chita Lighthouse, park volunteer James White is participating in the annual Christmas Bird Count and trying out his new binoculars. Volunteers are crucial to the park's operations. When open, the Boca Chita Lighthouse provides a stunning aerial view of the park. In the background are the Ragged Keys (left), Boca Chita Key and its harbor, and the Atlantic Ocean beyond. (KH.)

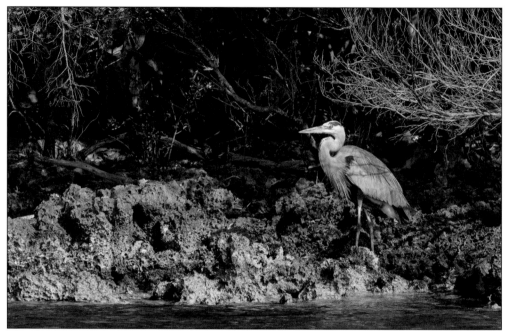

The shores of the keys are mostly rocky. The keys are made of Key Largo limestone, a fossil reef. Over the centuries, the limestone has been shaped and eroded by water, often to sharp, painful edges. The rocky shore supports an intertidal community, including snails, sea urchins, and crabs, and provides a feeding spot for this great blue heron. (KH.)

Lounging in an inflatable swan is one way to enjoy the park. Accessible beaches, such as this one at Elliott Key's University Dock, are much appreciated as sand is sparse along the keys, as illustrated by the narrowness of this beach. Sandbars along the channels of Biscayne Flats and between islands, such as at Sands Cut, are even more used, attracting hundreds of boats some weekends and holidays. (KH.)

Beaches expand and contract with the diurnal tide. At low tide, beaches may extend considerably. Most beaches form in the protection of coves, often having limestone rock exposed at the water's edge. Beaches serve as important habitat for shorebirds, marine birds, raccoons, and turtles. Annually, a dozen or so loggerhead turtles nest on Elliott Key's beaches. (KH.)

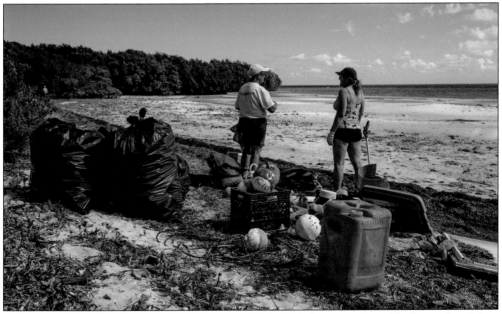

The park's shorelines accumulate the floating refuse of the passing world. Once, this debris provided early beachcombing settlers with valuable commodities that enhanced their survival. But today's trash is more persistent and a threat to marine animals, especially loggerhead turtles that nest on Elliott Key. This image is of park volunteers clearing trash from a sea turtle nesting beach prior to the beginning of the nesting season. (KH.)

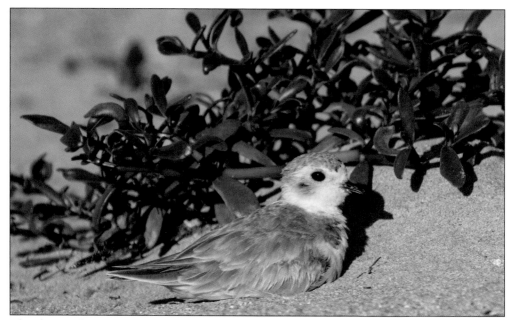

The shores of Biscayne Bay keys are habitat for shorebirds year-round but especially in winter. An endangered piping plover is shown here, tucking up against a sea purslane plant. Killdeer and Wilson's plover nest on the keys. Ruddy turnstones are one of the more likely noticed shorebirds because they roost on docks and boats and work the shorelines rather obviously, flipping materials they encounter. (KH.)

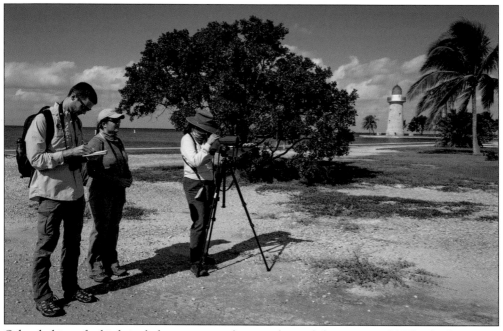

Other habitats for birds include mangroves, hammocks, and the water itself. This birding party on Boca Chita Key is participating in the annual Christmas Bird Count. Over 175 species of birds have been documented in the park. The Biscayne Birding Trail identifies worthwhile birding locations. (KH.)

No need for a motor or scuba tank to experience the water. Canoes, kayaks, and stand-up paddleboards all provide options for quietly seeing the underwater and above-water sights. This family is out on a weekend expedition in a double kayak. Paddle crafts allow visitors to explore shallow backwaters where motorized boats do not work. The quiet of paddling through the park's shallows is a respite from nearby civilization. (KH.)

A kid, a boat, a fishing rod, and a golden retriever— what of that is not part of a perfect family outing? Small boats allow families access to the shallow and offshore waters. Here, Alexandra Corwell and her fishing mate, Roxi, are fishing in the Biscayne Channel, which cuts through Stiltsville. Houses can be seen in the background. (KH.)

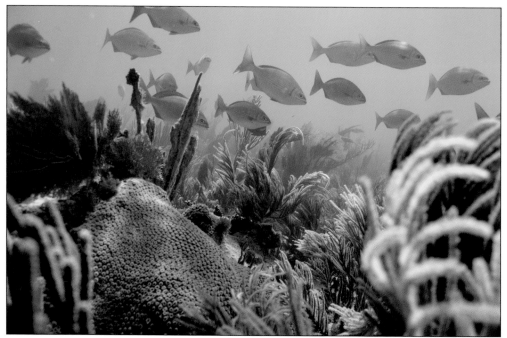

Coral reefs are among the most diverse ecosystems on earth. This single image suggests the diversity of massive hard corals, sea whips, sea fans, and reef fish. The reefs are home to spiny lobster, shrimp, sponges, and crabs. Over 500 species of fish are known from the park. This image was taken on the patch reef at Bache Shoal, named after the Florida reef tract's first surveyor. (PK.)

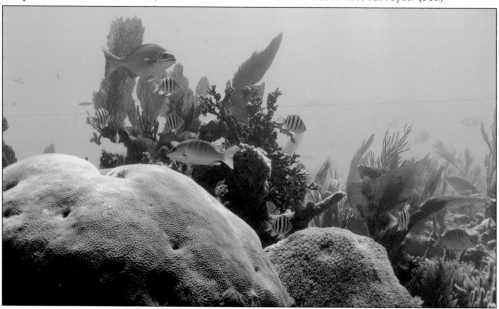

Boulder corals are the reef's building blocks, formed over the years as polyps accrete a skeleton of calcium carbonate. Star coral and massive starlet coral are shown here. Branching corals, such as staghorn and elkhorn, once covered the reef crest but are now endangered. Ocean warming stresses coral. In 2014 and 2015, prolonged high temperatures caused corals to bleach, which occurs when they expel their symbiotic algae. (PK.)

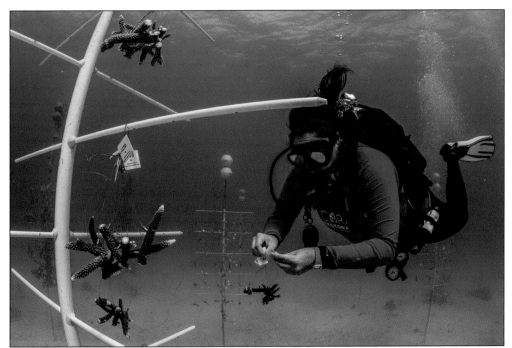

One possibility for restoring damaged reefs is outplanting nursery-maintained corals. The park collaborates with University of Miami Rosenstiel School of Marine and Atmospheric Sciences to rehabilitate broken corals for restorations within the park. The Coral Restoration Foundation maintains several nurseries south of the park for branching corals, such as this one being tended by Jessica Levy. Northern Key Largo's Ocean Reef Club supports one of these nurseries. (CRF.)

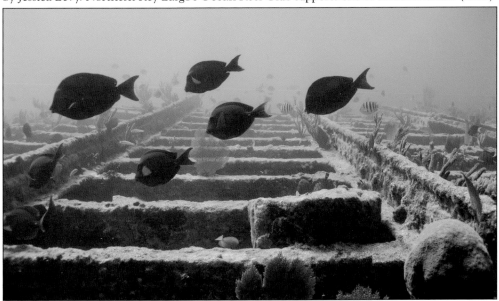

Wrecks provide another reef enhancement process as they become colonized by reef organisms. These artificial reefs attract both fish and divers. Shown are the reef-encrusted remains of the *Erl King*, a 306-foot, three-masted steamship that crashed into Long Reef in 1891. She lies in only 18 feet of water, readily accessible to snorkelers and divers. (PK.)

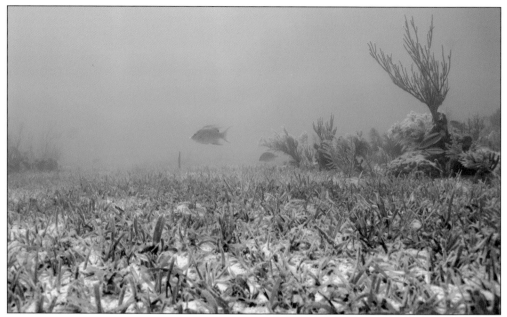

Seagrass beds of varying density develop on sandy or muddy bottoms (foreground), whereas hard-bottom communities occur where limestone is closer to the surface (top). Turtle grass is the predominant seagrass in the park. Others are shoal, manatee, and the endangered Johnson's seagrass. In hard-bottom communities, sponges, soft corals, calcareous algae, and brown algae, such as sargassum, attach to the rocky bottom. (PK.)

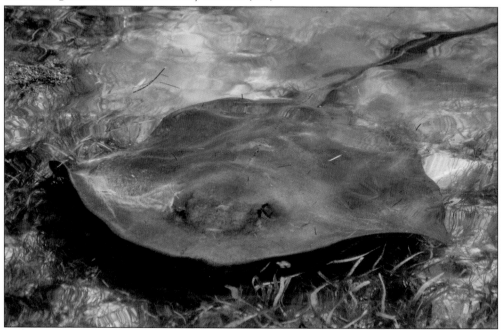

Bay-bottom communities support a diversity of snails, clams, worms, pink shrimp, sea urchins, and species of fish. These shallow, protected waters serve as nursery grounds for juveniles and also provide food for larger predators. Stingrays, shown, are one of the larger species to be observed patrolling shallow seagrass meadows for food, often surprisingly close to shore. (KH.)

84

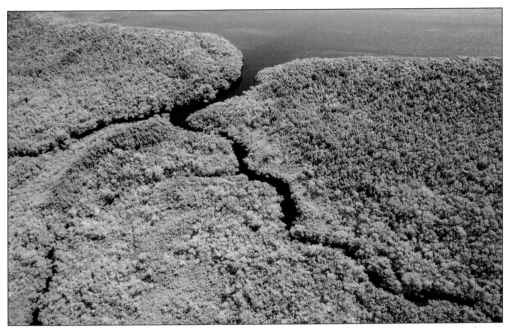

Red mangroves line much of the shorelines of the keys and the mainland. Mangroves, tropical trees that uniquely live in saltwater, provide resilience to storms and habitat for a diverse community of algae, oysters, and other invertebrates and juvenile fish within their prop roots. Along the mainland, some of the coastal mangroves fringing the park retain their natural physiognomy. Shown is a mangrove-lined stream entering the park. (KH.)

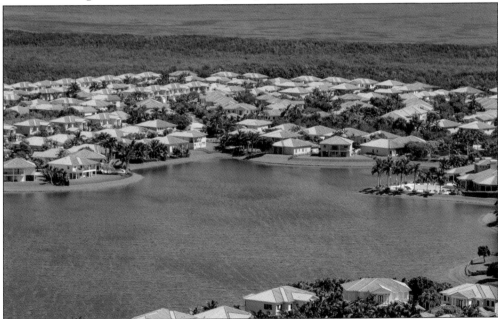

Although the western shores of the park remain to a large extent fringed by mangroves, the forest is far less extensive than it used to be and is now backed not by miles of wetlands, but by homes and other developments protected by levees. Sometimes, the pristineness of the park as seen from the water is a bit of an illusion, with civilization nibbling at its edges. (KH.)

Found near and in the coastal mangrove swamps, the mangrove cuckoo specializes in capturing large insects, especially caterpillars. This is a Caribbean and Central American species found in the United States only along the southern mangrove-lined coasts of South Florida. Biscayne National Park is one of the best places to see a mangrove cuckoo and other mangrove-specializing birds. (KH.)

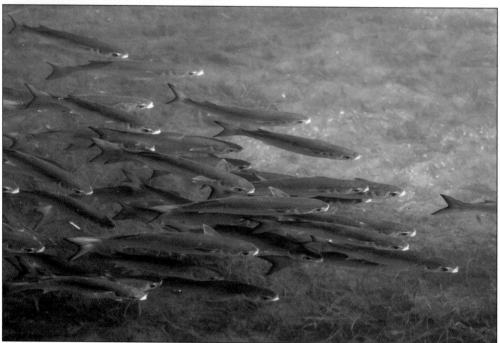

Mullet of several species occur in the park, the most common being the striped mullet. Mullet arrive in South Florida in numbers during their fall migrations, where they provide food for snook, tarpon, and many other predators. Mullet occur along the shores and in streams, lagoons, and mangroves but also in the open bay where schools, such as this one, feed along the bottom, creating "mullet muds." (KH.)

Mullet is also a primary food of osprey, which feed by grabbing fish with their talons. Several pairs of osprey nest in the park, as shown in this image from Elliott Key. In winter resident ospreys are joined by migrant birds from the north. Bald eagles also occur in the park, although only one nest has been reported, in 1994. (KH.)

One of the more obvious of the park's waterbirds is the brown pelican, which dives from the air plunging into the water to scoop up fish with its massive bill and expandable throat pouch. Pelicans nest on islands in northern Biscayne Bay. In the southern bay, they can be seen feeding, roosting on pilings or mangroves, and flying from place to place in V-shaped flocks. (KH.)

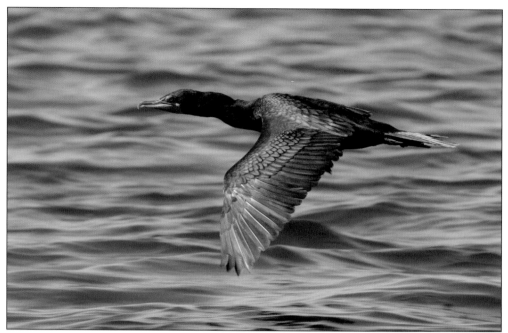

The double-crested cormorant is the most abundant waterbird in Biscayne Bay. On average, about 1,000 cormorant nests occur in the park each year at seven sites, the largest colony being on Ragged Key 5, which is easily observable from Boca Chita. They are seen throughout the bay and offshore waters, fishing while swimming underwater for their favorite prey, toadfish. (KH.)

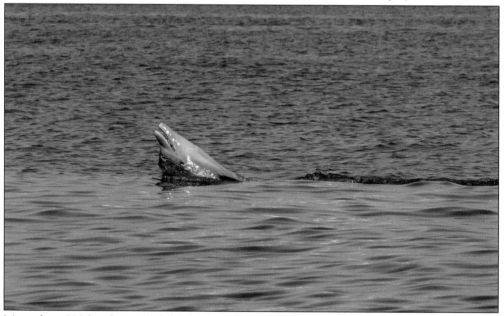

More than 200 bottle-nosed dolphins have been documented in Biscayne Bay, living in two genetically distinguishable social groups, one primarily in the northern bay and the other in the south. The southern group from Biscayne National Park has lower contaminant loads than those from the more human-populated northern bay. They eat mullet, pinfish, grunt, and crustaceans, and may ride boat bow waves or wakes. (KH.)

Loggerhead turtles, like the one shown here with accompanying remoras, are now the principal sea turtle found in the park, with a few nesting on the scarce beaches. Seagrass flats of the bay have always been an important turtle habitat, especially for juveniles. The green turtle, which supported the historic turtling industry of the bay, suffered massive population reduction by the 1940s due to overharvest. (CL-NPS.)

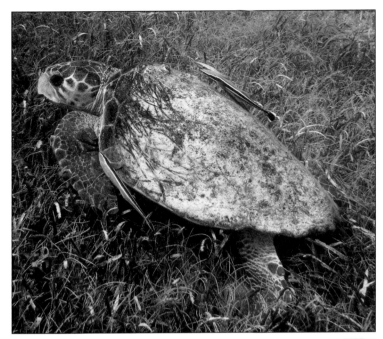

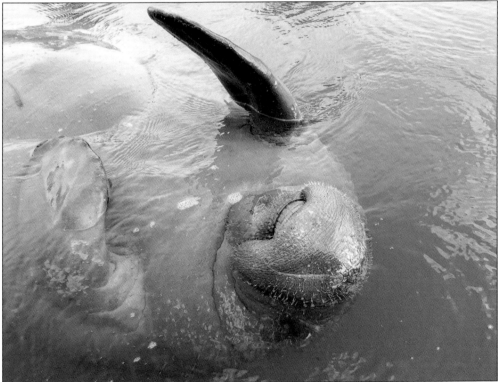

The West Indian manatee has always been an important element of Biscayne Bay's biological and cultural history. It is a federally listed species, owing to its susceptibility to collisions with powerboats and to periodic cold snaps. Although year-round residents, their numbers in Biscayne National Park increase during the winter as manatees migrate south for warmer water. (KH.)

On Elliott Key, nature has recovered from hurricanes and the purposeful creation of Spite Highway, which now is but a narrow footpath through native tropical hammock. West Indian plants recolonized the bulldozed ground, as they have other previously cleared areas of the islands. Biscayne National Park now protects one of the largest and most diverse remaining stands of West Indian hammock in South Florida. (KH.)

Evidence of the first generation of pioneers is scarce. The Sweeting plantation, abandoned in the 1930s, has been reclaimed by Elliott Key's vegetation, with the help of hurricanes. Pictured is one of the remaining foundations marking the family's 50 years of farming and living on Elliott Key. (KH.)

Nor is much left of the Jones family residence on Porgy Key. The steps and foundation of the main house remain as a memorial to the family's history on Biscayne Bay. Lance Jones never returned after being evacuated for Hurricane Andrew, ending nearly a century of the Jones family on the bay. (KH.)

Few plants remain from the agricultural days of the keys, understandably given that many decades and hurricanes have passed. This sapodilla tree persists on the Totten Key farm site of the Jones family. Sapodillas, once grown for their sap and fruit, seem to do well surviving and reproducing in the native hammock vegetation and so persist where the early plantation owners put them. (KH.)

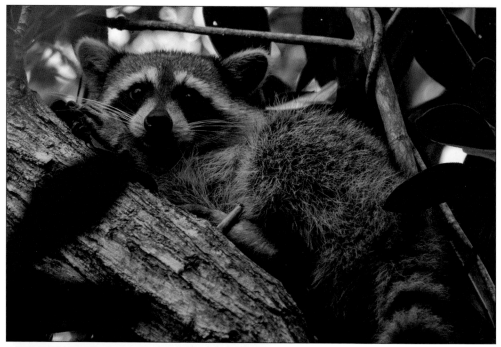

The most commonly observed land mammal in the park is the raccoon, found on both the keys and the mainland. It forages along the sandy or rocky shores and sleeps in the tree canopy during the day. It is a devoted omnivore willing to eat a nearly endless variety of food and can become a scavenger at places people visit, which is discouraged. (KH.)

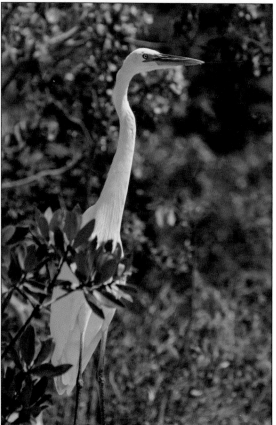

Considered a color morph of the great blue heron, the great white heron is not an uncommon sight in the park, nesting at as many as six sites and averaging about 22 nests per year. This is a prime example of the park's tropical fauna, as it is a bird restricted to shallow tropical bays, such as Biscayne and Florida bays. It stalks the shallow waters for fish. (KH.)

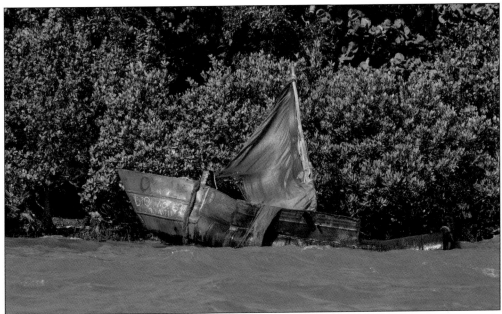

Not unlike the 1800s or 1900s, the southern Biscayne area continues to be a place where people from elsewhere come to escape. This refugee boat lies beached on Elliott Key, just the latest following in the wakes of Native Americans, Ponce de León, Spanish, Bahamian Conchs, Americans pioneers, rumrunners, Cuban refugees, the wealthy, and the poor. Protected waters of Biscayne Bay welcomed them all in their passages. (KH.)

The sun sets next to Miami's modern trash midden, the South Dade Landfill, also known as Mount Trashmore. On southern Biscayne Bay, the sun setting over the mainland often creates spectacular, quickly changing pallets of golds, oranges, and pinks that tint both the western and eastern skies. The landfill, now risen to be the highest point in South Florida, provides a winter sunset scene as viewed from Elliott Key. (KH.)

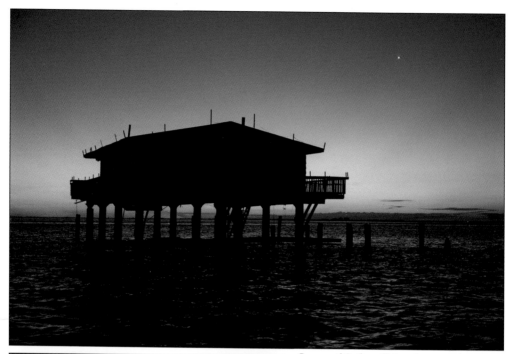

Some of Stiltsville's cabins in the sea remain. Less than a mile south of Key Biscayne and its lighthouse, now approaching 200 years old, Stiltsville continues to mark the Biscayne Flats. It is a reminder of the intriguing and sometimes odd human history of Biscayne Bay and is a gateway to Biscayne National Park and its natural wonders. (KH.)

In the mist of a winter sunrise, a boater ventures out into the bay from Convoy Point heading to a place that is ancient and modern, accessible and remote, familiar and mystical. Biscayne Bay has seen as many changes as there are varied moods of dawn. But Biscayne National Park will always be a place for future generations to be enchanted by a tranquil sunrise. (KH.)

KEY TO COURTESY LINES

Images in this book appear courtesy of the following photographers and sources:

AT-NPS: Photograph by Arend Thibodeau, courtesy National Park Service
BS-NPS: Photograph by Brett Seymour, courtesy National Park Service
CL-NPS: Photograph by Charles Lawson, courtesy National Park Service
CM-HM: Photograph by Claude Matlack, courtesy HistoryMiami
CRF: Coral Restoration Foundation
GK-HM: Photograph by George Kochaniec, courtesy HistoryMiami, Miami News Collection
HHPL: Herbert Hoover Presidential Library
HM: HistoryMiami
HM-MNC: HistoryMiami, Miami News Collection
HM-RVW: HistoryMiami, R.V. Waters Papers
JN: John C. Nordt III, MD, Collection
JW: Joe Wasilewski Collection
JWC: Florida Keys History & Discovery Center, Jerry Wilkinson Collection
KH: Photograph by Kirsten Hines
KH-NPS: Photograph by Kirsten Hines, artifacts courtesy National Park Service
K-H: Kushlan-Hines Collection
KLAC: Key Largo Anglers Club
LBJPL: Lyndon Baines Johnson Presidential Library
LM: Courtesy Lloyd Miller, *Biscayne National Park: It Almost Wasn't*, 2008, LEMDOT Publishing, Redland, FL
LMC: Norman B. Leventhal Map Center, Boston Public Library
MCPL: Monroe County Public Library
NOAA: National Oceanic and Atmospheric Administration, Department of Commerce
NPS: National Park Service, Biscayne National Park and the South Florida Collections Management Center
ORC: Ocean Reef Club
PG-HM: With permission HistoryMiami, from *Tequesta: The Journal of the Historical Association of Southern Florida*, No. 56, Paul S. George, editor
PK: Photograph by Philip F. Kushlan
RM-HM: Photograph by Ralph Munroe, courtesy HistoryMiami
RM-JN: Photograph by Ralph Munroe, courtesy John C. Nordt III, MD
RM-MCPL: Photograph by Ralph Munroe, courtesy Monroe County Public Library
SAC: National Park Service, Southeast Archeological Center
SAF: Florida Memory, State Archives of Florida
TC-HM: Photograph by Tim Chapman, courtesy HistoryMiami, Tim Chapman Collection
UCL: University of California Library
USFWS: United States Fish and Wildlife Service National Digital Library

DISCOVER THOUSANDS OF LOCAL HISTORY BOOKS FEATURING MILLIONS OF VINTAGE IMAGES

Arcadia Publishing, the leading local history publisher in the United States, is committed to making history accessible and meaningful through publishing books that celebrate and preserve the heritage of America's people and places.

Find more books like this at
www.arcadiapublishing.com

Search for your hometown history, your old stomping grounds, and even your favorite sports team.

Consistent with our mission to preserve history on a local level, this book was printed in South Carolina on American-made paper and manufactured entirely in the United States. Products carrying the accredited Forest Stewardship Council (FSC) label are printed on 100 percent FSC-certified paper.

MADE IN THE
USA